P9-DMC-070

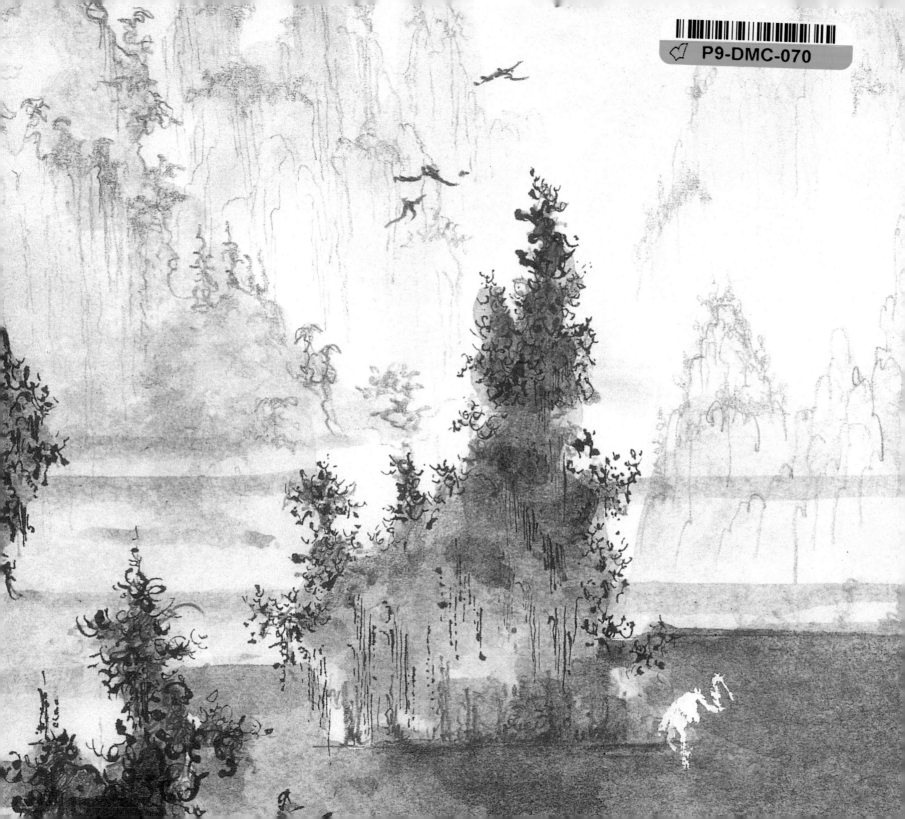

THE
SILK
ROUTE

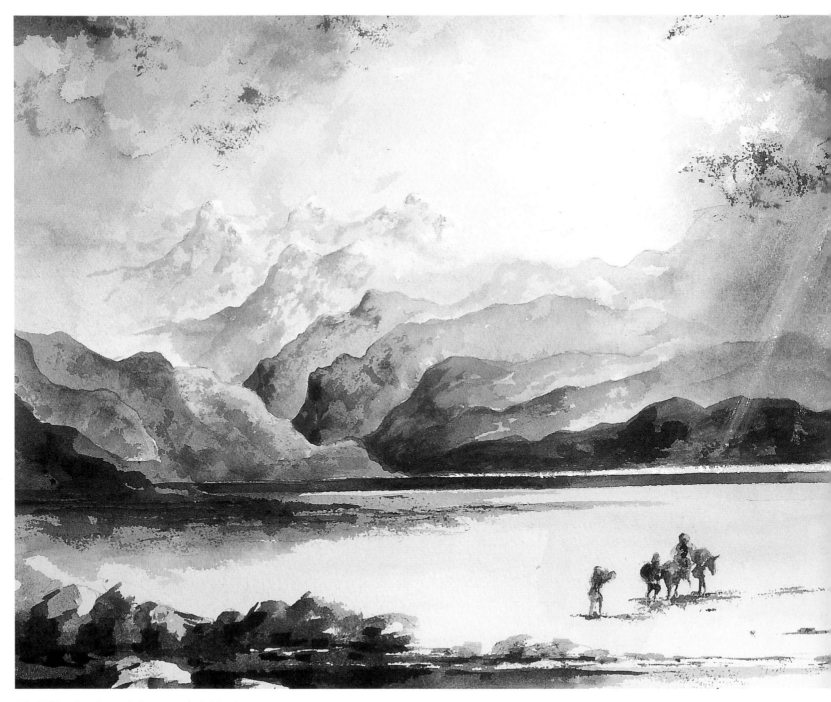

The Taklamakan Desert, looking towards the Tin Sian Mountains

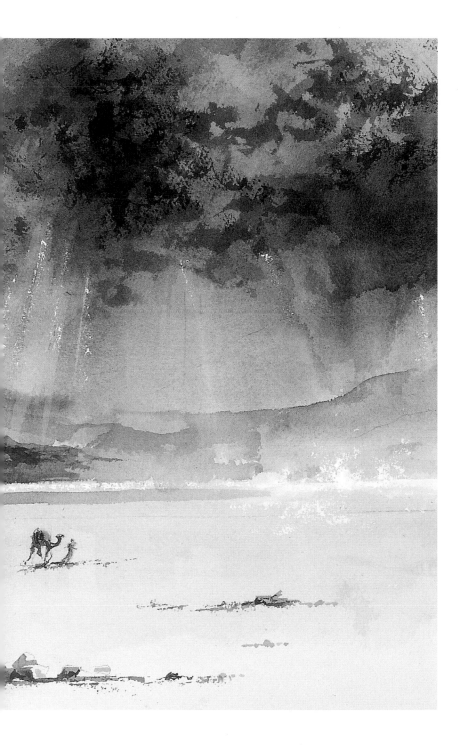

THE SILK ROUTE

From Europe to China

HARRY HOLCROFT

PAVILION

To Sarah

First published in Great Britain in 1999 by
PAVILION BOOKS LIMITED
London House, Great Eastern Wharf
Parkgate Road, London SW11 4NQ

Text © Harry Holcroft, 1999
Illustrations © Harry Holcroft, 1999
Design and layout © Pavilion Books Ltd.

The moral right of the author has been asserted

Designed by Bet Ayer

All rights reserved. No part of this publication
may be reproduced, stored in a retrieval system, or
transmitted, in any form or by any means, electronic,
mechanical, photocopying, recording or otherwise,
without the prior permission of the copyright holder.

A CIP catalogue record for this book is available from the British Library.

ISBN 1 86205 322 7

Set in Venetian
Printed in Singapore by Kyodo Printing Co.(S) Pte Ltd
Colour Origination by DP Reproductions

2 4 6 8 10 9 7 5 3 1

This book can be ordered direct from the publisher. Please contact
the Marketing Department. But try your bookshop first.

CONTENTS

FOREWORD

This book is a collection of extracts from my sketchbooks and
diaries compiled over ten years of travelling. As an artist my reason for travelling
was always visual, so it is essentially a picture book.

However, during endless hours on trains and boats, in buses and terminals,
in scruffy uncomfortable, dirty rooms throughout the Eurasian landmass,
I always recorded my thoughts as well as my sketches.

The pictures speak for themselves. My thoughts, though, are nothing more
than an interpretation of circumstances and events as I have perceived them.
They are not necessarily correct, far less politically so. But they are mine.

All pictures in this book are in the hands of Private Collectors.
I thank them for their patronage and continued support.

*The book is set out geographically rather than chronologically,
so diary dates and events do not necessarily follow sequence. Narrative in italics
are those extracts taken directly from my diaries.*

INTRODUCTION

Provence, France
LE MOURRE DU BES, LACOSTE
Breakfast, Saturday, 2 July 1994

*T*he sky is violet with sunshine. I am in the garden eating a croissant. A large blob falls in the butter — it is a mulberry.

I blink, rub my eyes, look at it and try and think — not easy for me in the morning.

In 1400, Le Mourre du Bes, our home, was a small silk factory supplying Lyons and the Burgundian dukedoms with silk.

Silk is produced by the thread of the cocoon, spun by the silk worm (a small white caterpillar — the product of rather a dull-looking moth). It feeds off the leaves of the mulberry. Hence the mulberry trees, and a mulberry in my butter.

I am not Mr Newton with his apple. However like so many things in our lives, something insignificant and simple causes a chain reaction that leads us to goals we would never have even contemplated.

A kernel of curiosity is established. We are drawn in like a fish on the line. We begin to eat into an idea.

In this instance, I am suddenly drawn back twenty-five years, to an individual who was to influence the next five years of my life.

COLONEL FREDERICK GUSTAVOS BURNABY

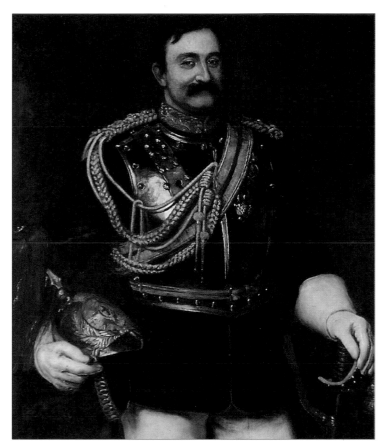

In 1971, after a year or two in my regiment, when I had settled down to a life of soldiering and painting, I discovered an extraordinary man behind a portrait on our mess wall at Hyde Park Barracks in London. He was Colonel Frederick Gustavos Burnaby.

Burnaby was the classic Victorian Empirical hero, prodigiously strong – said to be the strongest man in the British Army. Standing 6 ft 4 ins, weighing 15 stone, he could lift a small pony under each arm. At a mess dinner, when the Prince of Wales was the guest of honour, he demonstrated his strength by bending a poker around the royal neck.

However, he was not only brawn: he was a gifted linguist fluent in seven languages including Arabic, Russian and Turkish, as well as being able to write brilliantly. The Colonel became an occasional correspondent for *The Times* and at one time obtained an advance of £2,500 – an unheard of sum in those days – to write about his adventures in Ottoman Turkey – one of the initial countries in 'The Great Game'. (We will come to that later.) Burnaby had an enquiring mind and believed that British Army officers of that time had a duty to devote the considerable free time available to them in benefiting their country, as many did. Thus he set off with his servant Radford to investigate Asia Minor both strategically and economically.

Burnaby was especially interested in Russia's designs on India and Turkey. The former fortunately came to nothing, but the latter ended in war. He amassed an incredible amount of detailed military knowledge of this vast region of enormous geographical and climatic contrasts.

So, with pencils, sketch pads, and paints, I started out on a succession of journeys which took me along part of the way of my former brother officer: through Russia, the Middle East, Central Asia and eventually to China, to the source of the Silk.

SILK: THE LEGENDS

Five thousand years ago Xiling Shi, wife of the Chinese Emperor Huangde of The Xia Dynasty, is also sitting in her garden under a mulberry tree in what is present Xian. A cocoon that this insignificant caterpillar produces drops into her teacup.

She picks it out of her tea and finds herself unravelling a long piece of amazingly thin white thread. She has discovered what will be China's most valuable and distinctive product – silk. It will be the very basis of China's future Imperial wealth.

For the next 4000 years China produces the woven threads of the silkworm's cocoon, with absolute control over the knowledge of its production. Silk literally becomes 'worth its weight in gold', due to this monopoly and the extraordinary qualities of the material.

The Chinese Empire flourishes while the only other glimpse of civilization that appears in the whole of the Eurasian landmass is that of the Achaemenians in present-day Persia, around 500 BC. By then, the Chinese Mandarins have already been sitting civil-service exams for 4000 years.

By the time of Christ and the Roman Empire, China learns of another power bloc far, far away. They begin to investigate.

So developed the Silk Route. Roman emperors and patricians dressed in their togas desired silk. Thus the greatest trade route in history developed. It became a route not just for silk but every other imaginable commodity, and, more importantly, ideas and religions crossed the Eurasian landmass.

Eventually, however, the monopoly is finally broken. Around AD 500 another Chinese princess, also called Xiling Shi, is married off as part of a 'treaty' to the Emperor Justinian in Constantinople. She is horrified at being sent halfway across the planet and so she smuggles a handful of cocoons in her knickers (some say her hairstyle) as a simple 'two fingers' to her father. (It is probably more likely that the Nestorian Christians brought the secret over … but that is far less exciting.)

As a result, Byzantium becomes the great silk-producing centre, spreading silk through Western Europe. The Silk Route as such collapses and the Sea or Spice Routes take over. China goes into decline and total isolation for 2000 years until today.

And this is all the result of an angry princess and her knickers!

These two women are the beginning of a remarkable line of ladies I encounter along the Silk Route. Similar to England's Boedicia, Elizabeth I or Victoria, history throws up females who dazzle and redirect the course of events for better or worse.

The majority of them murdered their husbands!

The Silk Route is littered with them.

Guilin, China

THE SILK ROUTE

The Silk Route in fact is a slight misnomer. It was a series of trade routes stretching over 7000 miles that involved not just silk but every conceivable commodity. Though starting as trade routes, they became a pathway for the exchange of peoples, culture and religion in both directions.

For example, the spread of Buddhism from India to China and Japan in 500 BC rather than anywhere else was a direct consequence of the Silk Route. Paper and printing discovered in China enabled the early Buddhist texts to move into China. The oldest examples of printed words are in the many hundreds of Buddhist monasteries that exist along the route.

Similar inventions moved the other way, gunpowder, porcelain (china) – even the wheelbarrow. Peter the Great in the 1700s in Russia became obsessed with trying to discover the method of porcelain production but, as with the secret of silk production, he failed.

Although the Silk Route gradually declined after the fall of Byzantium, today the former Soviet Islamic states are experiencing a return to their old trading potential.

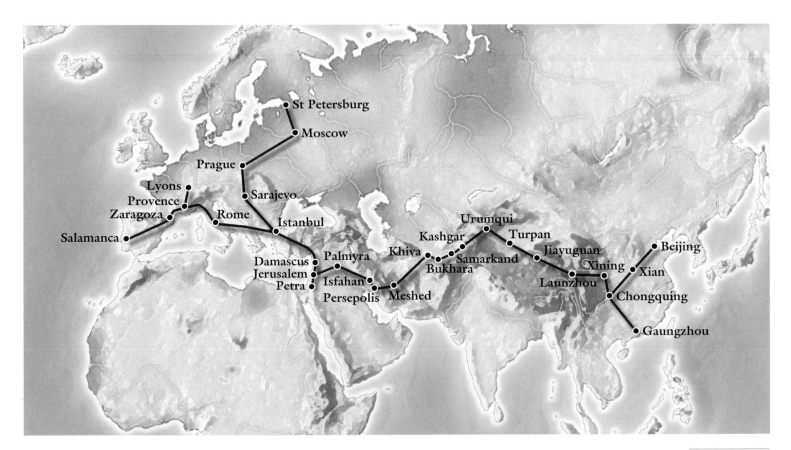

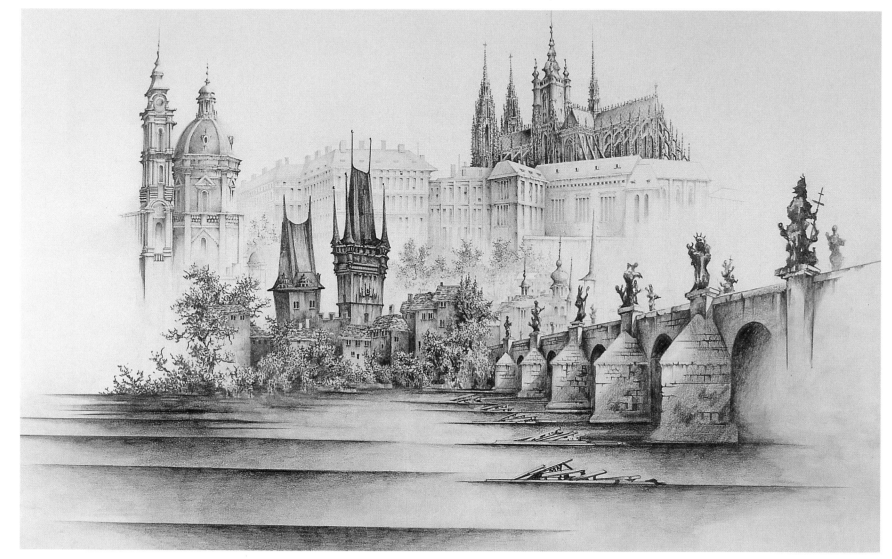

St Vitos Cathedral and the Charles Bridge, Prague

EUROPE

By the fifteenth and sixteenth centuries,
the royal courts of Europe were providing the market for silks,
then being produced wherever mulberry trees could grow —
tapestries for Paris, Burgos and Lisbon; Persian silk carpets
for Orléans, Venice and London; not to mention
silk ribbons for King Charles II spaniels.

My route begins with Burgos in Spain and then proceeds via Russia and
the Balkans, following in the steps of Colonel Burnaby.

No. 108 "The Silk Route"

Sarragossa Cathedral

November 6 A.W. Hefferee 95

The city is horrible, but the cathedral extraordinary with strange size

SPAIN

Burgos
A MEAL ON THE ROAD
Thursday, 14 May 1998

*D*riving along endless motorways. No cars but thousands of gross, smoking lorries. Where are they all going? Spain is a vast desert, covered by motorways, full of these juggernauts going backwards and forwards. What on earth for? A mammoth spaghetti junction appears — only reason being a small village, but the real reason — it's a lorry drivers 'pit-stop'. There are over 200 juggernauts parked outside this eatery.

Having travelled the whole Silk Route this meal takes the biscuit. Two hundred male hulks are sitting in this cavernous hall. Each has literally a gallon flagon of wine in front of him. Everyone has a fag in their mouth. The density of smoke makes any concept of passive smoking ludicrous. At the side of the hall is a room. It is, after investigation, a gigantic oven. Very stout Spanish ladies with legs like tree trunks go into the oven by a door. Within minutes they reappear, very red, carrying steaming trays on which are huge carcasses of indeterminate animals, ribs akimbo, and great lumps falling on the floor. Sometimes I have felt the Chinese the most irreverent of eaters, but what I am witnessing is unsurpassed. They are burying themselves in blubber.

My Spanish is adequate. The dialect and Menu, however are incomprehensible. One of the large red ladies says there is a lot of 'Careta y oveya de porcino'. I recognize the 'porcino' bit (pig). I say yes. I continue to marvel at this feeding frenzy when a large steaming pig's head is matter-of-factly put in front of me. It looks at me, and I look at it. When confronted with a head, what do you eat first?

I have eaten strange things in my life, from raw monkeys in Ethiopia, to live sea slugs wobbling across your plate in the fish markets of Tokyo, but eye-to-eye with a pig is a challenge.

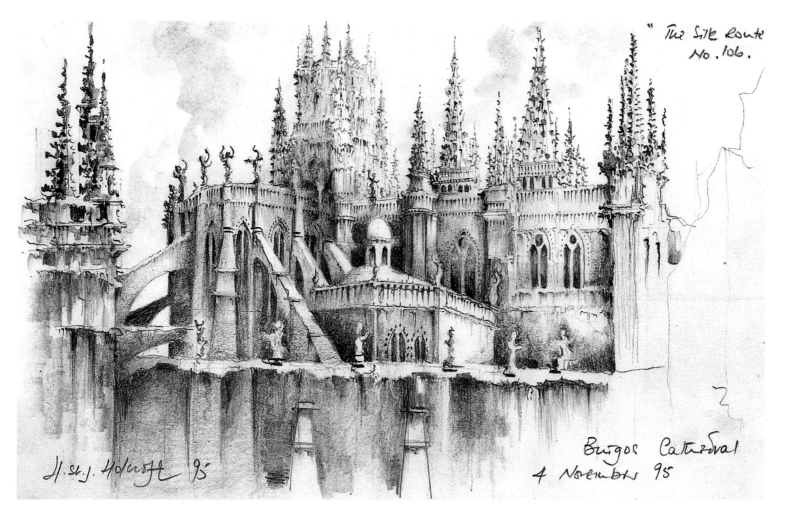

Burgos Cathedral
4 November 95

H. St. J. Holcroft 95

Burgos cathedral, Spain

Is a knife and fork relevant? Chopsticks? Do you nibble an ear? Gouge out an eye? Suck the tongue — bite a nostril? There seemed no guidance or etiquette that I perceived, just more carcasses of flesh, together with the red ladies coming from the oven. How alien I felt — and this is Europe! It was delicious!

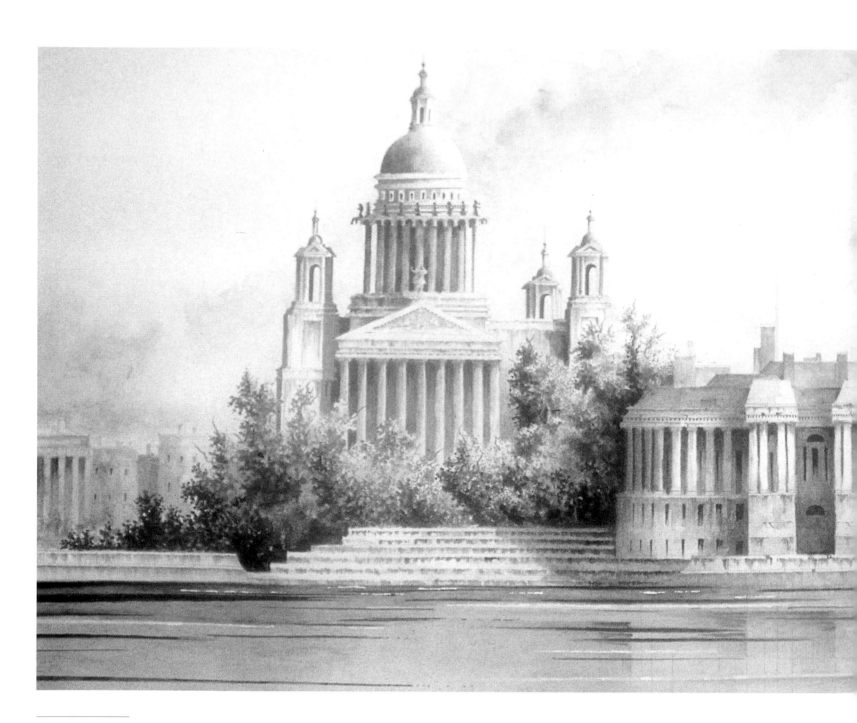

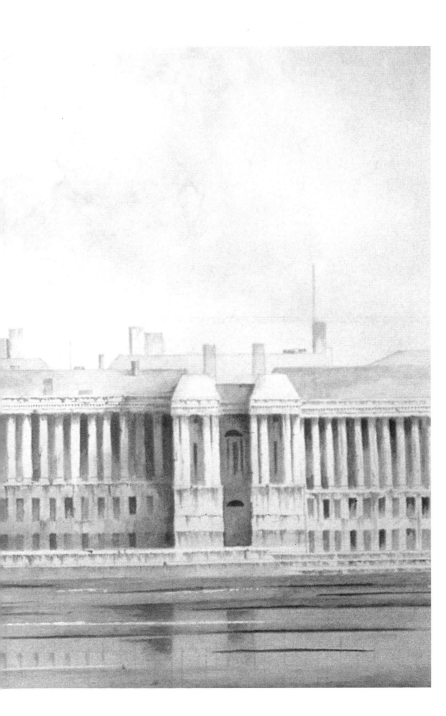

RUSSIA

PETER THE GREAT

He stands as one of the most influential of modern rulers. He dragged Russia single-handedly into the modern age. As soon as he became Tsar in 1685 he embarked on his great fact-finding mission to Europe, the first Russian ruler ever to leave the country.

On his return two years later things changed. He embarked on a war with Sweden to bring Russia to the Baltic, built a vast city, St Petersburg, to control it, including St Isaacs Cathedral which could have been transported from Venice, took over the Church (becoming its head and destroying the yoke of conservatism), destroyed the nobility to produce a government based on meritocracy, founded a navy, expanded Russia into Siberia and also into Central Asia along the Silk Route, and still had time to visit the sick in hospital and make lots of wooden toy boats on his lathe!

Only a woman could have done more. And thus Catherine the Great carried on Russian expansion thirty years later. Another formidable lady along the Silk Route.

Yes, she murdered her husband!

St Isaacs Cathedral, St Petersburg

Moscow
TVERSKAYA (OFF RED SQUARE)
Monday, 20 April 1992

I had been indoctrinated about 'The Great Russian Bear', hovering ready to swallow Europe. From becoming a soldier in 1969, twenty-two years of the Cold War taught me nothing else. But despite the facts, something never quite rang true.

Then The Wall comes down. I leave the army, and I now sit for my first night in Moscow. I am in an apartment of three rooms with a Russian family of five. There is no heating and no hot water. Outside it is cold and miserable, inside it is the same.

I can already tell that there was no Great Russian Bear — as we were told. Just a Politburo, frightened and power-crazed who felt threatened. And yes … perhaps a Russian general might have gone for the button! But the people? The kindest and sweetest. I have arrived with a rucksack and one huge suitcase full of nothing but chocolate, soap and green apples. I am like Father Christmas, and they are heart-warmingly thankful even if we have no common language. However, despite their warmth they are morose and apathetic. Their history for 500 years from Mongol subjection to Tsarist serfdom to Leninist sovietization has been one of inhumane manipulation. Now the authority is 'The Mafia'. Within three months of my being with the family a whole protection racket has started on this street alone. Two menacing black cars stand silently twenty-four hours a day at either end of the street. No form of economic freedom can happen. The population, as they always have been, are helpless.

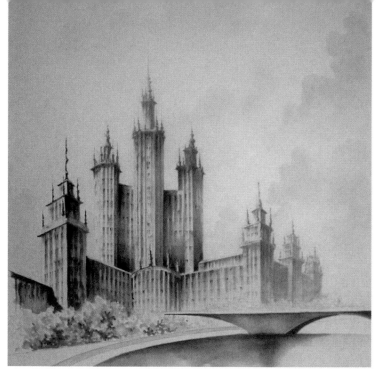

ABOVE: *One of Stalin's 'wedding cakes', Moscow (note the similarity to the Kremlin built 600 years previously)*

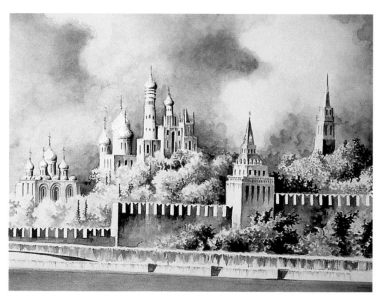

ABOVE: *The Kremlin, Moscow*

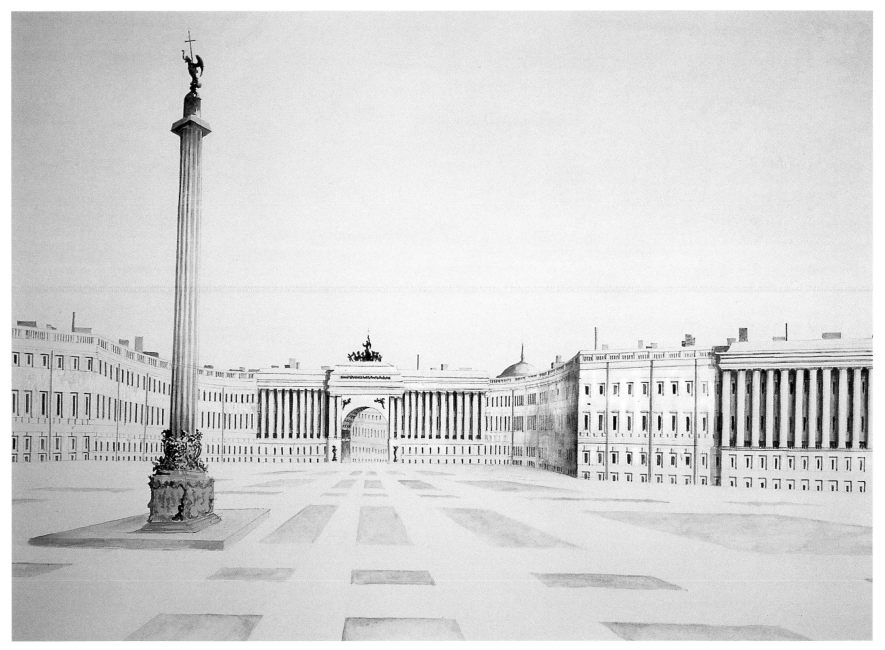

The Grand Military Arch, Military Headquarters, St Petersburg

Moscow
TELEPHONES AND FLAGS
Friday, 12 June 1992

*N*obody gets out of bed until eleven or twelve. There is no point. No work, no shops — nothing to do.

Except the telephone! — It's free.

The whole day is spent sitting around the kitchen table with a packet of fags, tea, and the telephone stuck to their ears talking to anybody and everybody. The cost of the whole population doing this must be horrendous. One reason the place is dying on its feet.

Petrol is virtually free. So if they go out at all they pile into someone's car. Today I joined them. We are driving down a Moscow street. We suddenly drop into a huge hole in the road. The car is vertical and totally stuck. We are all very shaken.

'Why is there no red flag in the road to show danger?' I say.

My friends reply smiling, 'There is a red flag to signify danger. You saw it when you crossed the border into Russia!'

St Petersburg
A SOVIET SOLDIER
Sunday, 14 June 1992

*S*upper with a friend of the family. He was a soldier. His name is Igor.

At staff college, while being told of the danger of the Great Russian Bear, we were also told of its limitations.

A particular one was 'drink'. The extreme example. Tank crewman lying underneath the engine sumps and drinking the anti-freeze... As 'sober' Western soldiers we laughed. 'But yes!' cries Igor. 'Many times we drink antifreeze. You haf not bin in Russia alone at night in winter. We were drunk or ill all the time, tanks would not move — no antifreeze — Igor drink it all. Yaa!'

From this one surmises that the Soviet divisions would literally have never moved!

St Isaacs, St Petersburg

St Petersburg
NUCLEAR SCIENTISTS
Monday, 15 June 1992

Sitting with Sarah (my wife) in the only workable hotel in St Petersburg. I am concerned: every other female is on the make. The only access to any money (i.e. the dollar) is prostitution. Nonetheless, we are joined by two Americans. They are scientists, brought in to assist the collapsed Soviet nuclear programme.

We thought Chernobyl was bad but listen to Gus (that's his name):

'Hell – walk into this control room – Harry I tell yer – two dudes in white coats, asleep at their consoles, above them, this big dial – fifties design – one side black (normal), one side red (critical). This is core temperature.'

'Hell – this guy has stuck a goddamn screwdriver through the dial to stop the needle going critical! We have melt down on the other side and they're asleep with a screwdriver in the dial!'

The mind reels!

Church of the Spilt Blood, St Petersburg

THE BALKANS

Banja Luka: Bosnia
CONFLICT
Friday, 7 November 1997

I have rarely been so depressed in my life. To witness what has just happened in Europe with such savagery is appalling. Bosnia is three hours' drive from Venice. Yet for hundreds of miles every village has been systematically razed to the ground.

In Cerbach just north of here the DNA count in the lakes is higher for humans than it is for fish. That is how many bodies were dumped in the lakes during the slaughter.

If I mention an abattoir, a conveyor belt and children's amputated torsos on hooks — perhaps there's an idea of the horrors that have happened here.

United Nations Protection Force aiding the Moslem minority, Banja Luka, Bosnia.

WHAT ARE 'THE BALKANS'?

Simply a large mountainous area separating Asia from Europe. Today it means Albania, Greece, Bulgaria and what was Yugoslavia. The Balkans have always been Europe's 'flashpoint'. This is where Islam spread to and stopped in AD 600. A power vacuum was the result. It is still there but its problem is much deeper and more complex. Conflict, both today and in history, is normally neighbour versus neighbour whether for territorial, economic or religious reasons. There are always two protagonists:

> *Greek/Parthian*
> *Rome/Carthage*
> *Christian/Islam*
> *Arab/Israel*
> *France/England*

and on and on through history.

The common result is you make an ally out of your neighbour's neighbour. The natural ally of England, despite this century, is Germany. We still have a German monarchy and have done so since 1720.

The Balkans, like the Lebanon, are different. The Balkans have between nine and twelve protagonists. It's like a wedding cake. Let me explain.

THE FIRST LAYER:
Serbia – Orthodox Christianity – Slavic – backed by Russia.
Croat – Roman Catholic – backed by Germany.
Islam or Moslem – seemingly supported by no one.

THE SECOND LAYER:
Serbs who are Catholics.
Croats who are Orthodox.
Serbs or Croats who are Moslem.

THE THIRD LAYER:
Serbs who are ethnically Croats.
Croats who are ethnically Serbs.
Moslems who may be either or neither.

Put all this in a geographical melting pot, where any combination can live next door to any other combination, and it is not surprising that the Balkans can never hold together.

If the lifetime for an individual spans five generations (you know your grandparents and should live to know your grandchildren) then people of the Balkans have witnessed exactly the same tragedy every generation (twenty-five years) for the last century:

> *The two Balkan wars*
> *Two world wars*
> *The present chaos.*

The reason is 'the sins of the fathers'. If as a child you witness the slaughter of your parents and siblings and survive the horror, it does not disappear. Retribution occurs when that generation reaches adulthood.

I fear it may happen in twenty-five years after the present turmoil, as it may again in Northern Ireland.

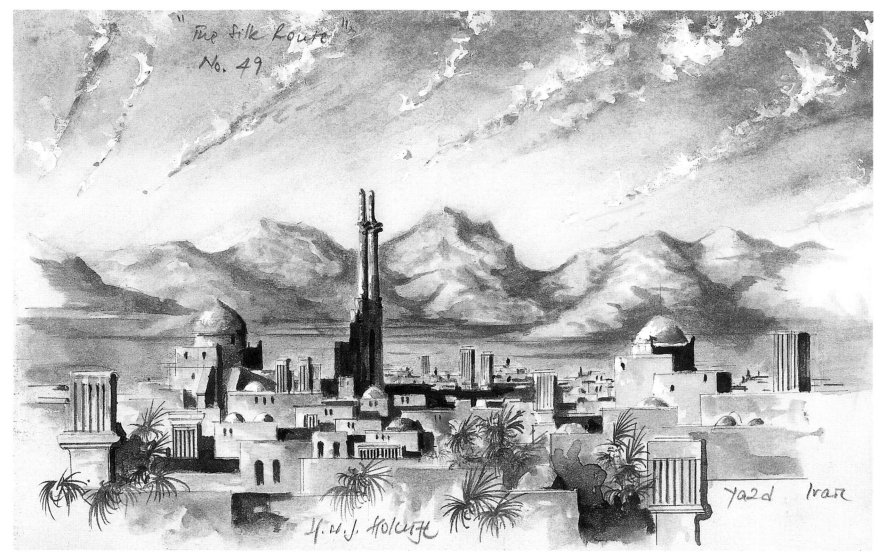

Yazd, Iran

THE MIDDLE EAST

The birthplace of Islam. In AD 630 the followers of Mohammet, 'God's Prophet', burst out of the Arabian Peninsula, sweeping aside all political and religious institutions before them.

Within 500 years the Dar-al-Islam, or the State of Islam, stretched continuously from Spain across North and East Africa, through the Middle East, Central Asia and India and into Southeast Asia.

Its central language and script was Arabic, and travellers or caravans leaving Spain 1000 years ago along the Silk Route could travel all the way to Java in Indonesia and never feel they had left home, so profoundly did Islam affect the people who embraced it.

And all this from an isolated windswept 'dustbowl' called Mecca.

TURKEY

ISTANBUL

Surely one of the most romantic cities in the world.

Byzantium, then Stamboul, then Constantinople, then Istanbul. Each one conjures up something a little different.

I first came here as a young soldier nearly thirty years ago. At the time it was my first feel of what I perceived as the decadence of the Orient. Visions of harems, intrigue, pleasure and executions gave me goosebumps.

Today, although it has everything of a modern metropolis, it has not lost what I felt then – this extraordinary bridge between Christianity and Islam; Europe and Asia.

Supposedly founded by one Byzas, in 657 BC, it became known as Byzantium. It fell to Rome in AD 196 and became the capital of the Eastern Empire and eventually the whole Roman Empire after the sack of Rome by the Visigoths in AD 410. This was Byzantium's glory, until it finally fell to Islam and the Turks in 1071. There followed two hundred years of conflict during the Crusades until the Ottomans finally established their own empire.

The Ottoman Empire kept expanding until Islam was at the gates of Vienna by 1683. However it failed to take the city and from then a slow decline began. Nonetheless it continued, even if in decline. The Imperial House of Osman was still involved in the peacemaking at the end of the First World War over three hundred years later. The Hohenzollerns, Romanovs and Hapsburgs were all gone.

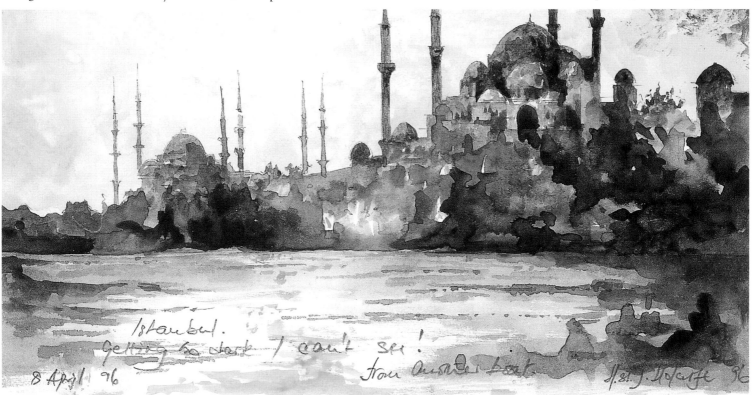

Istanbul. Getting so dark I can't see! from another boat. 8 April 96

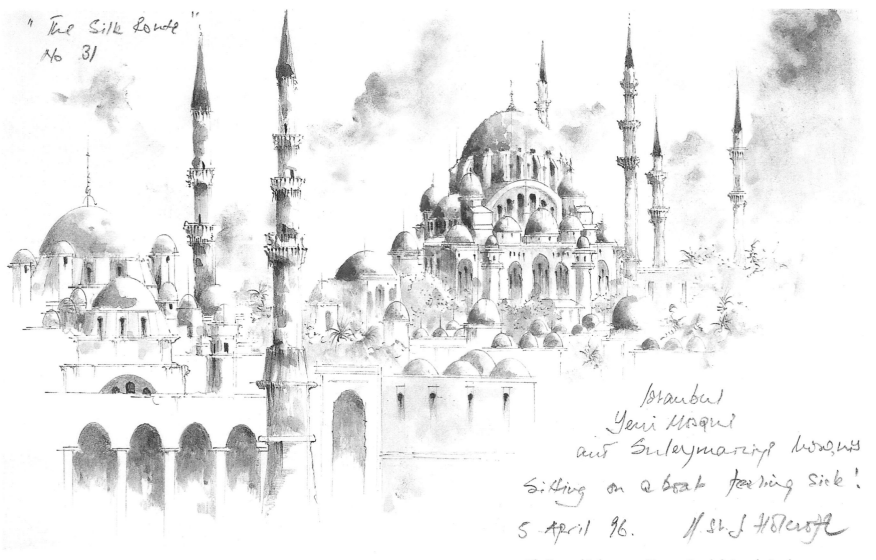

"The Silk Route"
No 31

Istanbul
Yeni Mosque
and Suleymaniye Mosques
Sitting on a boat feeling sick!
5 April 96. H.St.J Halcroft

ABOVE: *The Yeni and Suleymaniya Mosques, Istanbul, from the Bosphorus*

LEFT: *Istanbul from a boat under Galata Bridge on the Golden Horn*

SYRIA

The Crusader Castles
KERACK, SYRIA
Tuesday, 13 October 1996

*O*ne of the most dismal parts of Christendom's history must be the consequences of the Crusades. This remains one of the most uneasy relationships between the West and Islam. It still colours all our international politics.

The more I travel through the Islamic world, the more I am attracted by it, if one accepts the monotheistic Judaic inheritance that Christianity and Islam share. Ultimately, however, beliefs take me further east to India and China, where the possibility of a superior Deity does not hold such importance – and the spirit there dwells more on personal enlightenment.

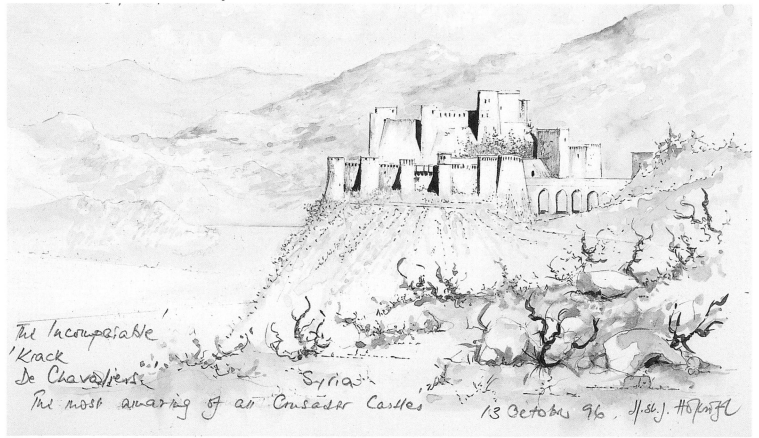

The Incomparable 'Krack De Chevaliers' Syria
The most amazing of all 'Crusader Castles'
13 October 96. H.St.J. Hornby

Krack des Chevaliers, Syria

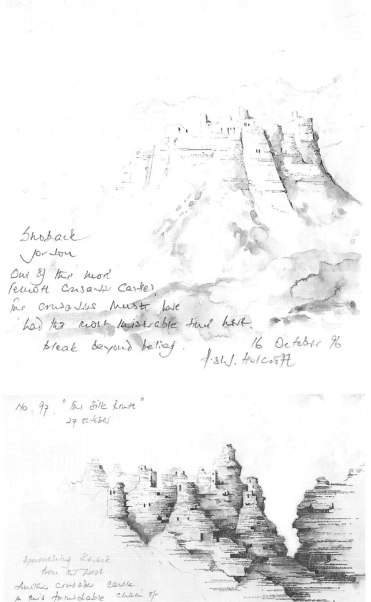

Shoback
Jordon
One of the most
remote Crusader Castles
the crusaders must have
had the most miserable time here.
Bleak beyond belief.
16 October 96
J.S.W. Holcroft

No. 97 "The Silk Route"
27 October

Approaching Kerack
from the West
Another crusader castle
in this formidable chain of
defences through Syria and Jordan
J.S.W. Holcroft 96

Nonetheless, Islam is beautifully simple. (It may not have the rigorous intellectual robustness of Catholicism and Orthodox Christianity, but it is a pure relationship of an individual and his spirit with his God — in total surrender. It has none of the 'mumbo jumbo' of Christianity produced by St Paul's concepts. Those with the Gift of Faith may be able to accept them. I sadly cannot.

The Crusades are the epitome of this juxtaposition. This was Christian fundamentalism, together with a large helping of economic advancement, at its worst. But the savagery and hatred that were the consequence are still with us in the bestial atrocities currently happening in Bosnia today.

Despite this, one can only marvel at the resilience of those early Crusaders. To have survived and built the incredible series of fortresses running through the Levant — from Turkey, through Syria, to Jordan — was truly a Herculean task. The heat and the isolation when clanking around in half a ton of tin must have been truly awful. Yet they built incomparable fortresses like Krack des Chevaliers, Marqueb and Kerack, hacked out of mountains on the most inaccessible heights.

How these people survived the most appalling hardship defies belief when you wander around the silent hilltops and skeletal ruins of these incredible fortresses.

And they were wondering whether the American soldier was even prepared to fight during the Gulf War … How soft the West has become.

TOP LEFT: *Sheback, Jordan*
LEFT: *Kerack, Jordan*

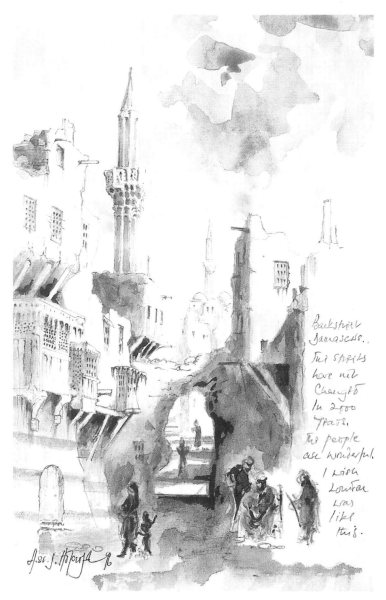

Damascus backstreet

DAMASCUS

It claims to be the oldest city in the world. Historically, it has to be the greatest trading city in the world, a biblical Hong Kong. 'The Street called Straight' from the Bible still exists as a vast bazaar that trades the same as it always has done.

It was supposedly founded by the sons of Noah (who also founded Khiva, of whom more later). Its fascination for me, however, lies in the profound effect it had on Christianity.

It was the great saint, Paul of Tarsus, a Roman living in Damascus who transformed the teachings of the man Christus into a form that the Roman world could assimilate beyond the confines of Judaism.

Jerusaleum may have given birth to Christianity, but it was Damascus that ensured its survival.

Damascus
ANOTHER MEAL
Tuesday, 15 October 1996

Why do I keep writing about meals? In the end, life revolves around a knife and fork, i.e. in China the greeting is 'Have you eaten?' not 'Good day'. Throw in some sex and that about encapsulates our lives — pathetic! This meal is in a very glitzy restaurant (by traditional Damascus standards), far from any 'Western' influence.

With normal incompetence and language barriers I attempt to order. This time, 'Sheep's Brains'. What I get has to be seen to be believed.

A silver dish arrives. On it is this vast 'thing'. It looks like an enormous meringue the size of a football — covered in ice cream with two huge wafers on the top.

This has no relevance, in my opinion, to what should be 'Sheep's Brains'. I will describe this culinary masterpiece.

It is indeed 'Sheep's Brains'. A whole brain has been wrapped in a huge ball of dough which has been soaked in yoghurt. It has then been put in the oven so the dough puffs up like a football. More yoghurt is then poured over it, looking like ice cream, and two large bits of fried bread resembling wafers are then stuck into it.

It is perfectly revolting. The brains are still raw and slop out like intestines. The yoghurt is rancid. The dough has taken on the consistency of soggy newspaper. This means one can't taste the brains, which is just as well — as they have been hanging in the window for a month — and the whole 'shebang' is floating on a lake of bicycle oil.

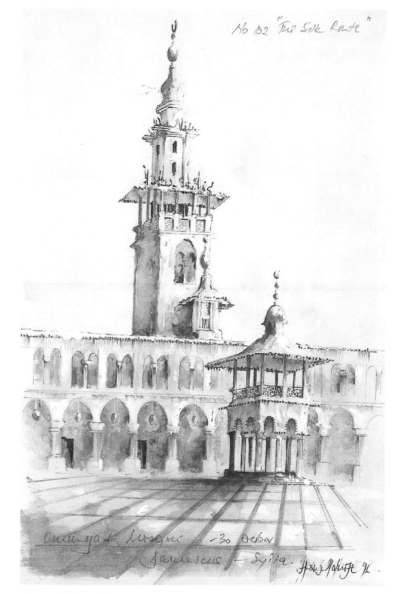

Omayad Mosque, Damascus

Oh ... for Provence and some foie gras *and a glass of* Sauternes!

PALMYRA

Palmyra, a name given by the Romans, means 'The Place of Palms', and that originally is what it was – a small oasis of palms in the middle of the Syrian Desert.

Like St Petersburg it was the most improbable of places for a city, but by 300 BC it was big enough to challenge Rome itself. With the emergence of the Silk Route, the Syrian Desert was a major geographical barrier to trade trying to reach the Mediterranean. Thus the oasis of Palmyra became pivotal.

By raising a camel corps to police the desert (riddled with tribal bandits) the Palmyrans provided a secure caravan route for the Silk Trade. By imposing taxes on goods passing through, and charging for water and even taxing prostitutes on the number of times they performed for the caravans, the money came rolling in.

By the time of the Emperor Hadrian in AD 100, while building his wall to keep the Scottish at home, a vast city of 200,000 was thriving in opulent splendour isolated in the middle of nowhere.

Today the ruins are quite spectacular, both in their size and their setting, and are blissfully unspoilt.

The Temple of Bel Palmyra, Syria

– Place absolutely deserted.

12 October 96
M.Sk. l. Honwth

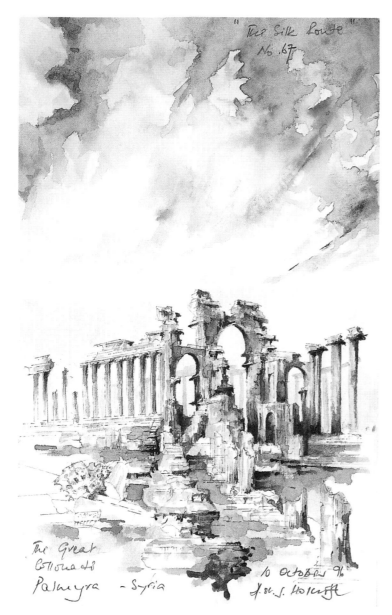

QUEEN ZENOBIA

A noted beauty and very dynamic, she was the wife of Odenathus, Palmyra's ruler. By AD 267, when Palmyra was at its most powerful, he was murdered in mysterious circumstances (rumour had it by Zenobia).

She declared herself Empress and decided to lay claim to the eastern half of the Roman Empire. At the head of her armies, she marched through present-day Turkey to Istanbul, and then back down the Nile, claiming she was a descendant of the Pharaohs.

Rome, understandably having been previously upset by everyone from Hannibal to Cleopatra, went after Zenobia in a big way. After three years' rampaging around the Levant, she was eventually defeated by the Emperor Aurelius.

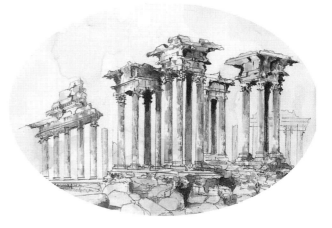

The Tetrapylon, Palmyra

The Great Colonnade, Palmyra

She was taken back to Rome and dragged through the streets in chains of gold, apparently very difficult to carry! Such were the riches of Palmyra.

The city, like Carthage, was obliterated and the inhabitants massacred, while Zenobia herself spent her retirement in a villa on Capri. Which is not a bad ending for a good-time girl!

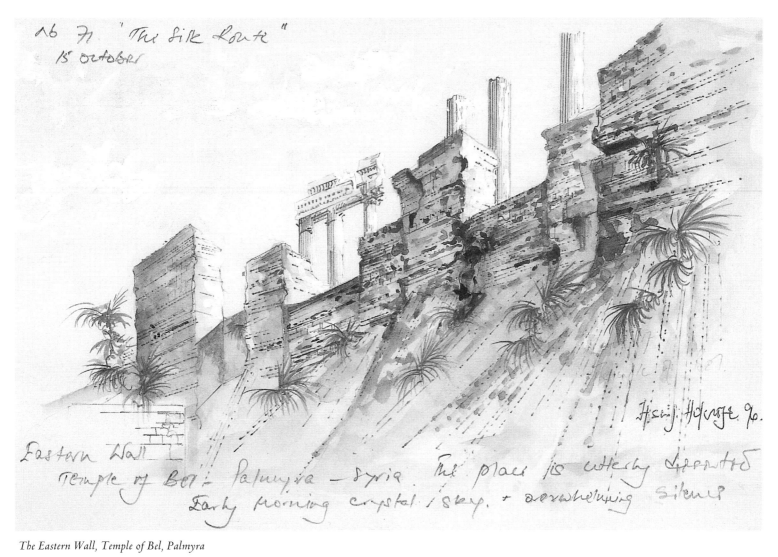

The Eastern Wall, Temple of Bel, Palmyra

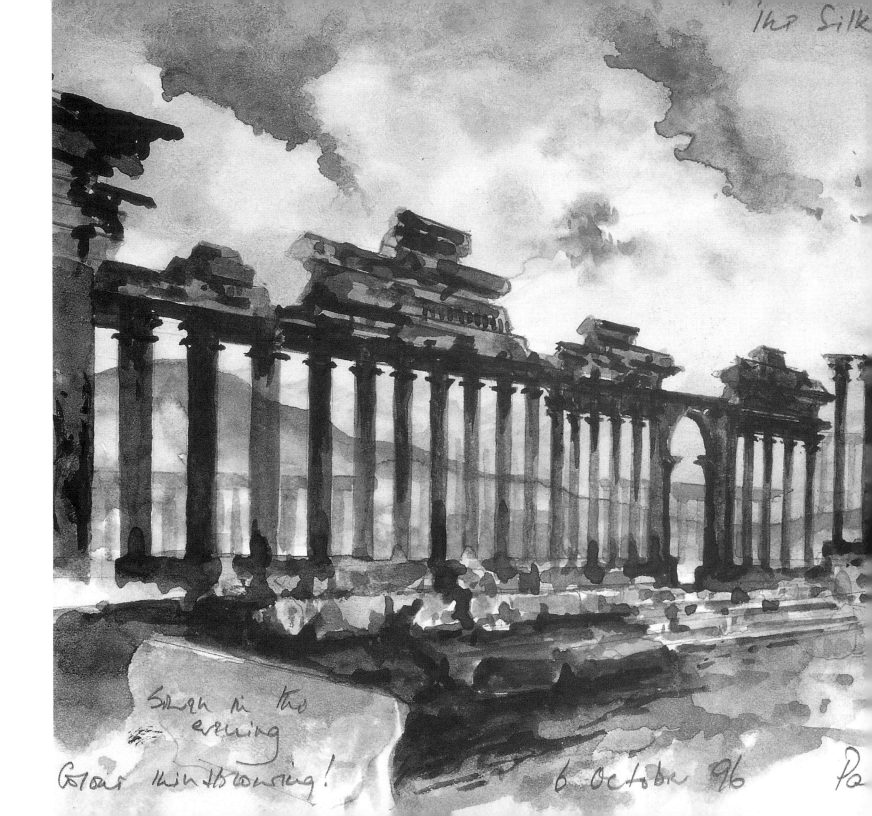

The Silk

Souqs in the
evening

Colour misbehaving!

6 October 96

Pa

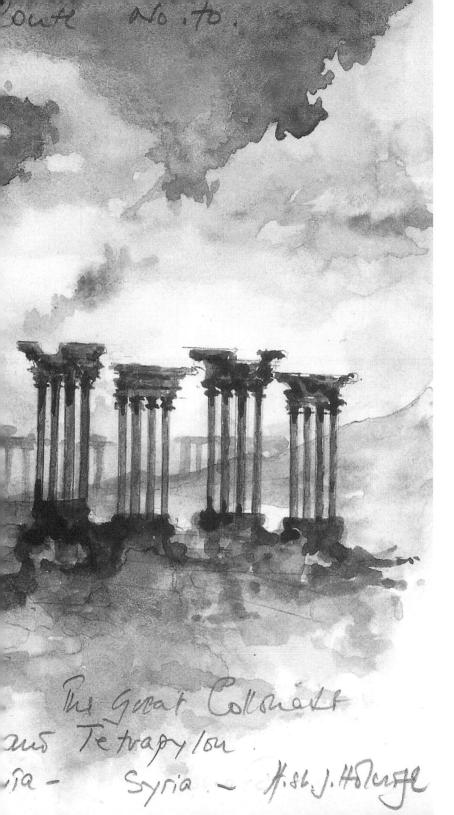

The Great Colonnade and Tetrapylon, Syria — [signature]

Palmyra
ABLUTIONS
Sunday, 20 October 1996

*D*ecide to visit the site of Palmyra at three o' clock in the morning. Incredible. The absence of humanity. The colours are somewhere in the ultra-violet spectrum with a sky that is blinding with stars and eternity.

I also take an adequate supply of whisky and soda. This I hope will add to the ambience of what is, in my mind, one of the most remarkable places on Earth.

While walking among these daunting, isolated columns, I am caught short with some form of Montezuma's revenge.

Nature must take its way; so by a suitable column I do what I have to. In normal Arab fashion I squat and then wish to carry out my ablutions – there is no water!

Why is an Englishman, in the middle of the night, in Syria, underneath columns of antiquity which must have seen everything, washing himself with a whisky and soda?

The Great Colonnade and Tetrapylon, Palmyra

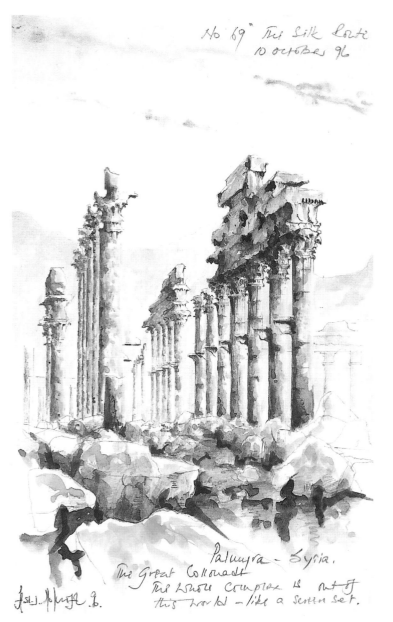

No 69 "The Silk Route
10 October 96

Palmyra - Syria.
The Great Colonnade
The whole complex is out of
this world - like a screen set.

The Great Colonnade, Palmyra

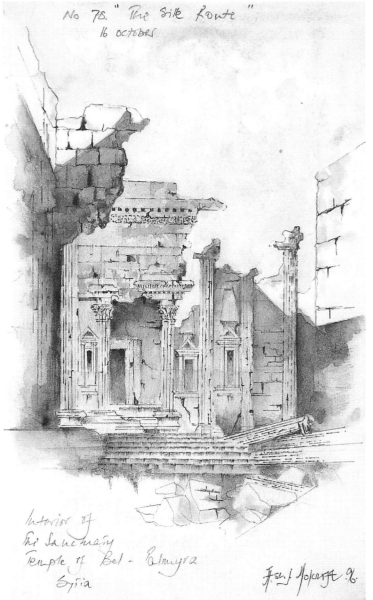

No 78 "The Silk Route"
16 October

Interior of
The Sanctuary
Temple of Bel - Palmyra
Syria

The Sanctuary, Temple of Bel, Palmyra

JORDAN

PETRA

The ruined capital of the Nebataean Kingdom predates the Silk Route, although it lies astride it. It flourished in 200 BC but became eclipsed with the rise of Palmyra.

Its existence, as with Palmyra, was based on controlling the trade routes that existed around the Arabian peninsular mainly of spice and frankincense. It remained independent of Rome but its architecture, like Palmyra, is classical.

The site was used by the Crusaders but eventually abandoned. Because of its position and isolation it became forgotten for 800 years, becoming the fabled 'lost city' until its discovery by the Swiss Explorer Burkhardt in 1812.

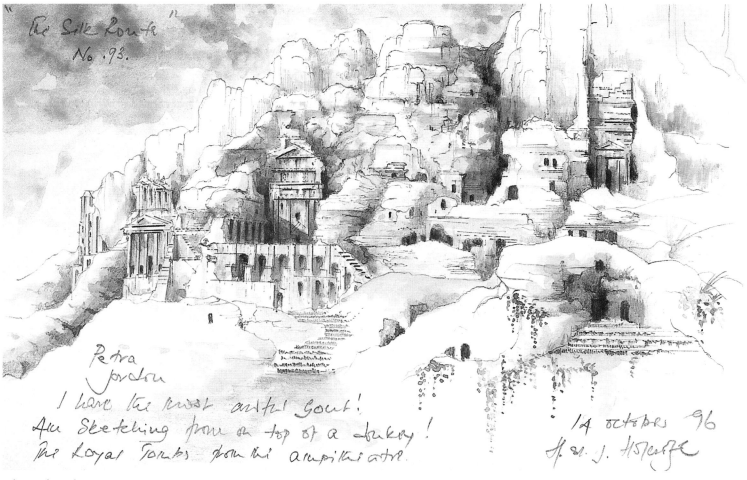

The Royal Tombs, Petra

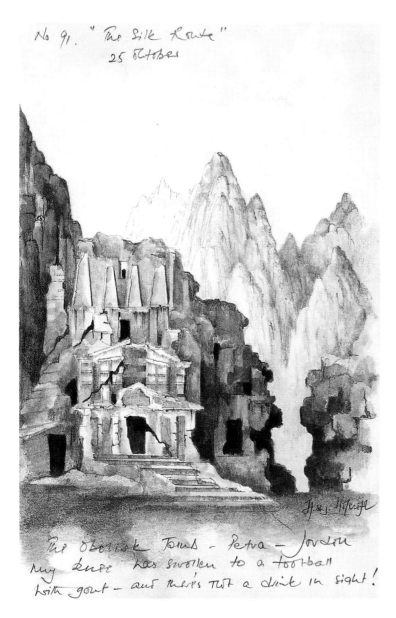

No 91. "The Silk Route"
25 October

The Obelisk Tomb - Petra - Jordan
My knee has swollen to a football
with gout - and there's not a drink in sight!

Petra
GOUT
Thursday, 28 October 1996

*M*y diet is entirely fruit — with watermelons the size of wheelbarrows. As I have an acidic metabolism — and don't even like strawberries — I get an appalling attack of gout, and I haven't had a drink for two weeks!

My knee swells to the size of a football. Having come this far, I am determined to continue and do some work. I hire a man and a donkey as I can't walk or do anything very much for a week.

I can't mount the donkey properly, so I heave myself on top and remain sitting side-saddle and off we go. As we arrive at Petra we wander through the busloads of tourists who look at me in amazement. I feel like Lady Godiva.

At various parts of the ruins we stop and the donkey is made to stand still, while I sketch from my position of vantage. It rarely stops, and together with the flies my sketches take on a rather loose feel, as if looking at a mirage!

The Obelisk Tomb, Petra

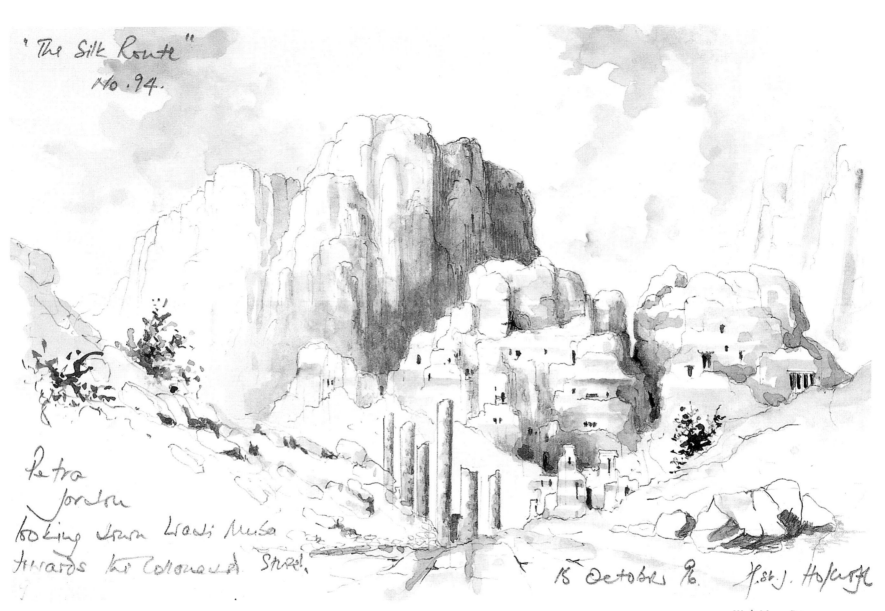

"The Silk Route"
No.94.

Petra
Jordan
looking down Wadi Musa
towards the Colonnaded Street.

15 October 96. H.R.J. Hopcroft

Wadi Musa, Petra

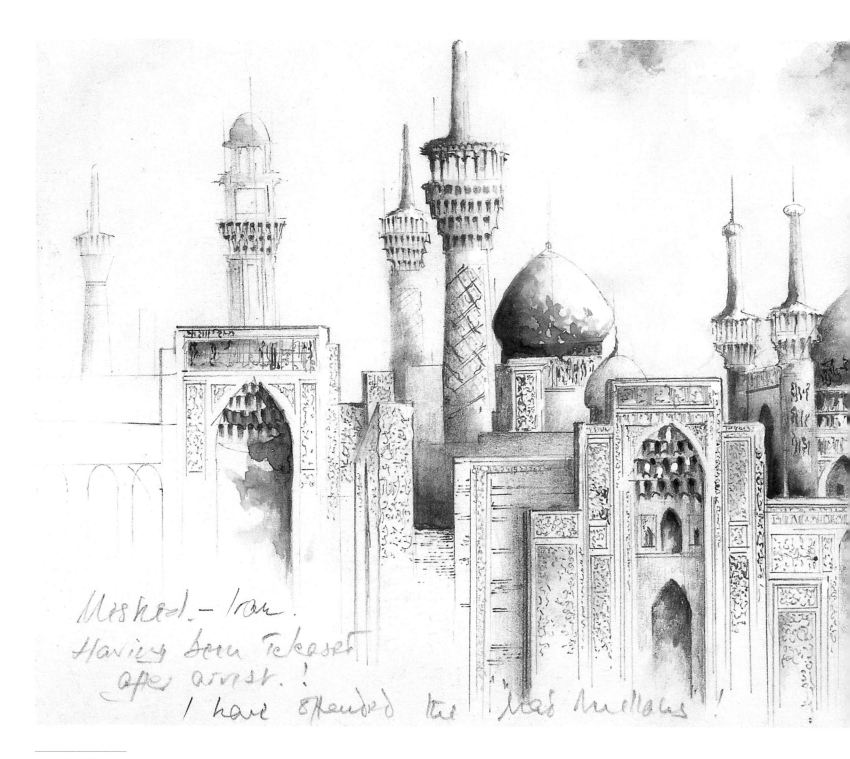

Meshed - Iran.
Having been Tckeasot
ager arrest.!
I have attended the "Mad Mullahs"!

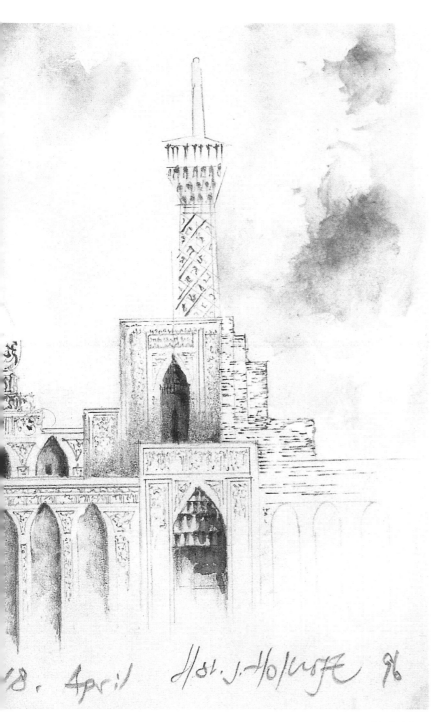

Mashed, Iran

IRAN

Persia
TEHRAN
Monday, 6 May 1996

The last time I was here was twenty-four years ago. It was the 2,500th anniversary of the Pahlavi Dynasty and the Shah was having a big party in Persepolis. Iran was bustling, noisy, polluted, rich, booming with oil largesse, and arrogance. The writing was on the wall.

However, the fundamentalist picture that the US propaganda machine has pushed out after the Revolution is exaggerated. If the US State Department continues to manipulate Islamic states, using Saudi as the policeman of the gulf as it did with Iran, and indiscriminately lobbing cruise missiles into Sudan, Libya and Iraq, it is hardly surprising that the US are regarded as The Black Satan.

Any form of fundamentalism is awful and the excesses of Christian fundamentalism as bad as Islam. But Iran is not that bad. The Persians are a proud, naturally courteous and friendly people. They are happy and eager to please and hospitality and kindness are second nature, like for the Syrians. I don't agree with blowing Americans up wherever they are, but I do have a degree of sympathy when US foreign policy is perceived from the Islamic point of view.

Sadly the Shah got it rather wrong and there was a very vicious backlash. Outside his old palace, a huge statue of him was torn down. All that remains are a gigantic pair of riding boots twenty-five feet high as a stark reminder of what Islam thinks of Western decadence.

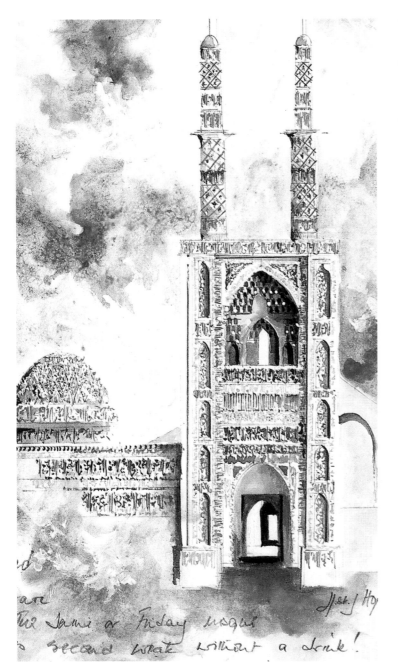

The Friday Mosque, Yazd

YAZD

THE ASSASSINS

In the remote valleys of the Elzburg mountains north of Tehran there grew up a bizarre religious cult which became known as the Assassins.

In the eleventh century a fundamentalist, similar to those of today, called Hasan ibn as-Sabbah, set up shop in the castle of Alamut. He drugged all his apostles on hashish and periodically sent them out to assassinate various rulers with whom he disagreed, much as fanatical suicide bombers are doing today. (The word assassin derives from hashish.)

The cult at its height in 1256 extended its reign of terror as far west as Syria and east to the borders of Pakistan. Like all fundamentalist groups its existence was short-lived but gave everybody a lot to talk about.

Yazd
THE TOWERS OF SILENCE
Wednesday, 8 May 1996

Yazd is the centre of Zarathustrianism. This religion is loosely based on the original gods of the Achaemenian Empire, and so is essentially Persian. It is thus (as the Armenians are) tolerated by Islam even under the fundamentalist regime of present-day Iran. However, there is a wonderful point of ridicule manipulated by the Islamic hierarchy.

Monotheistic overall, the bedrock of belief is that of the four Sacred Elements: Earth, Water, Fire and Air.

Death cannot come into contact with any of these elements, So huge towers are built which resemble a collection of Battersea gasworks. These are the 'Towers of Silence'. The dead are solemnly laid to rest on top of these towers. The mourners retire and the body is left to be picked to the bones by the birds, therefore avoiding decay by any of the sacred elements.

The Islamic twist is this: they have generated the rumour that if the dead loved one has the right eye plucked out first by a bird then he goes to heaven and if the left eye is plucked out first he goes to hell!

Consequently, all the relatives are hanging about on the edge of the towers, terrified out of their lives for the eternity of their relatives.

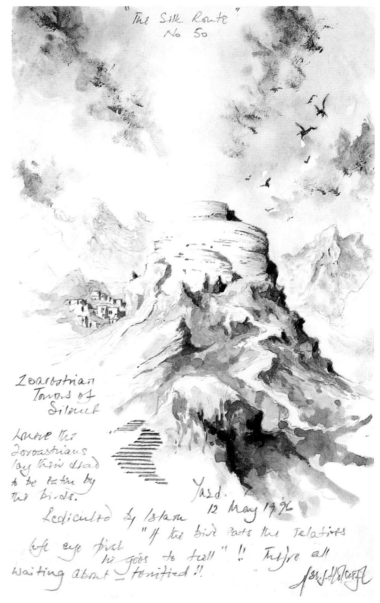

The Towers of Silence, Yazd

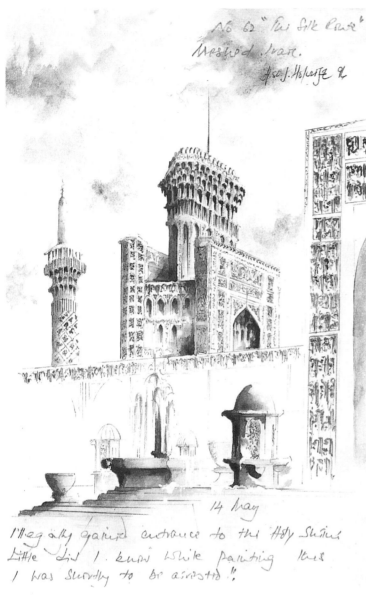

No 62 "The Silk Route"
Mashed. Ivan.
H.R.J. Holroyd 96

14 May

Illegally gained entrance to the Holy Shrine.
Little did I know while painting this
I was shortly to be arrested !!

Mashed

MASHED

Mashed
ARREST
Saturday, 11 May 1996

My wife Sarah is dressed in a chador. I am similarly Iranian-looking and she walks behind me. Thus, illegally we gain entrance to the Holy Shrine (the eighth Imam, the Shiites' most important after Mecca).

In order to sketch the Shrine, I leave Sarah on her own and find a small staircase to a balcony which offers the best view.

I sit outside a small doorway and paint. Shortly, a Mullah appears at the doorway. Seeing me producing an image he realizes that I am an infidel. He speaks a little English.

'You paint.'
'Yes,' I shrug despairingly.
'Allah is great.'

'God is great,' I reply as an electric tingle of forthcoming disaster goes down my spine. He bows very politely and disappears.

Two minutes later — whoosh! Five black SAS-type soldiers with UZI machine guns assault me and drag me off to a cell, amidst considerable screaming and commotion.

In this isolated fundamentalist theocracy suddenly being 'banged away' is a little unnerving, particularly as I am not sure I am actually ever going to get out.

What I don't realize at the time is that I have been sitting outside the office of Khomeni's Personal Representative in Mashed (in Western terms the equivalent of the Pope). It is not me personally that causes the concern, but the previous month sixty people had been slaughtered by a terrorist bomb within the Shrine while at prayer – totally unreported in the West. As a result, an infidel outside 'The Pope's' Office causes security to go berserk!

How do I escape? Sarah in her chador pleads my innocence and rescues me, after four hours of considerable concern.

Mashed. Painted in prison having been arrested

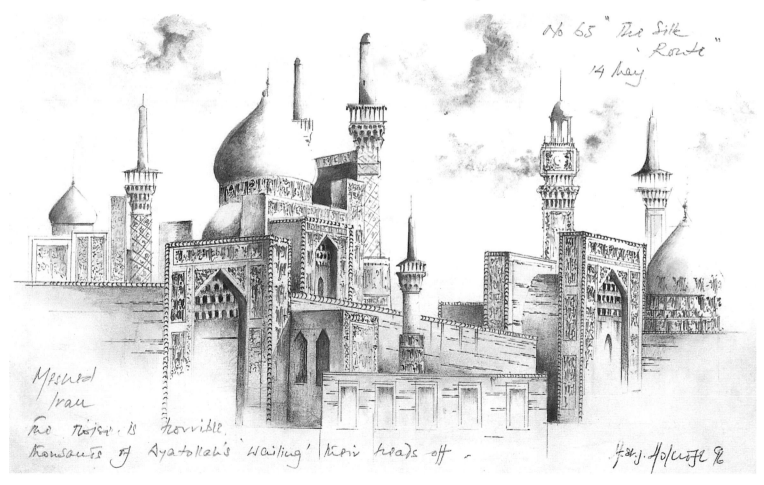

No 65 "The Silk 'Route'" 14 May

Meshed Iran
The noise is horrible.
thousands of Ayatollah's 'Wailing' their heads off.

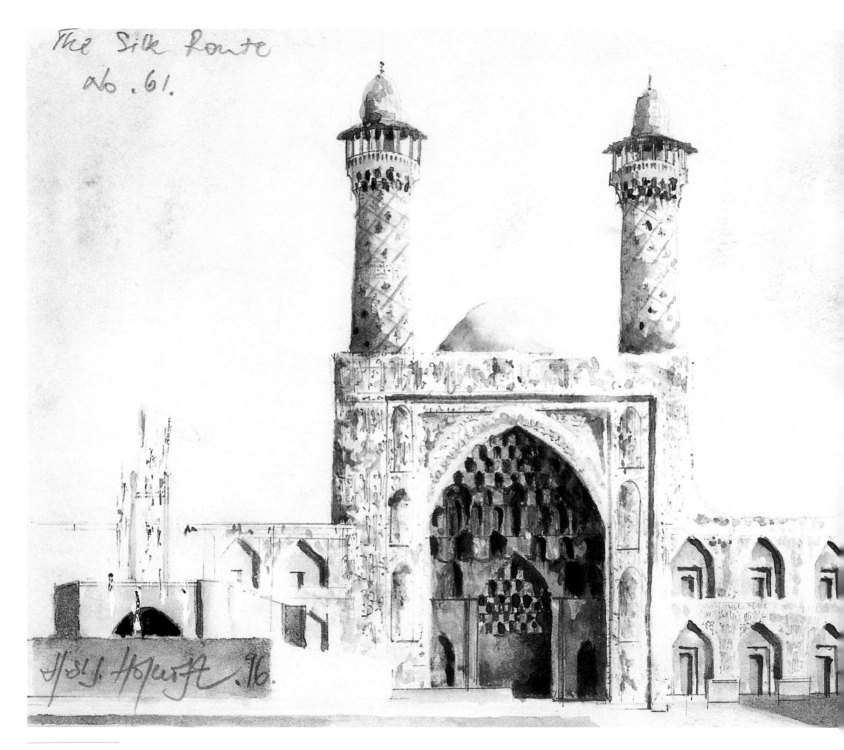

The Silk Route
No. 61.

ISFAHAN

Carpets. I can never think of anything else when I think of Isfahan. I bought my first Persian rug here thirty-five years ago.

By the seventh century when the Silk Route was at its most active, the silk carpets of Persia were finding their way back to the Tang dynasty in China.

To the Persians their carpets are their wealth, their joy and passion. This is not surprising. To look at a perfect silk carpet of the sixteenth to seventeenth centuries, designed to reflect the Persian love of gardens, to see it shimmering in sunlight with the light reflecting off the silk, is sublime. In terms of art it puts the Impressionists to shame by comparison.

Isfahan was one of the great carpet-producing centres, central to the Silk Route. It reached its zenith in 1587 when Shah Abbas became ruler and made it his capital. His breadth of vision in construction produced some of the most beautiful architecture in the Islamic world.

Friday Mosque, Isfahan

OVERLEAF: *The Bridge of 33 Arches*

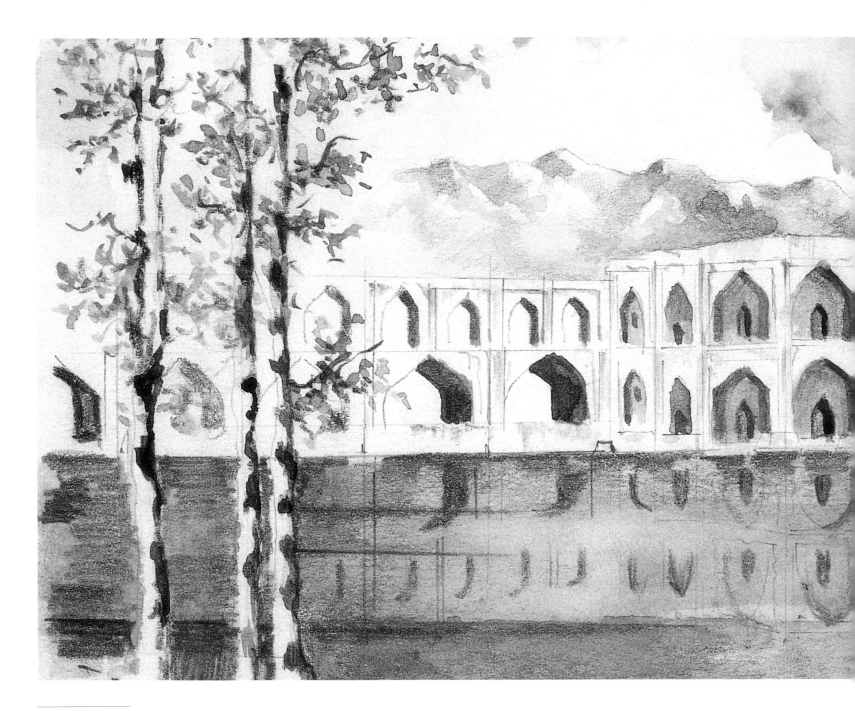

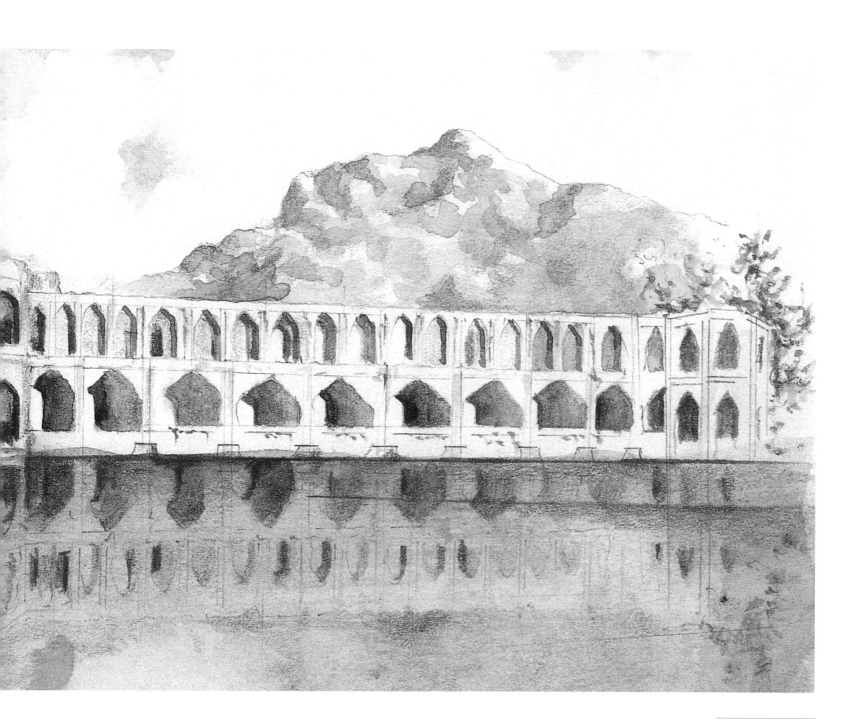

PERSEPOLIS

Persepolis was the capital of the first power bloc in the west of the Eurasian landmass that could be described as an empire – that of the Achaemeneans, the Persian Empire.

By 512 BC Darius the Great controlled everything from the Aegean to India. Here he built the massive temple complex of Persepolis. The size of the columns, like Baalbeck in the Lebanon, is inspiring. Built on a vast platform it overlooked the plains of southern Iran.

However, the Persian Empire was short-lived. Xerxes, Darius' successor was defeated by the Greeks at Marathon in 490 BC. By 331 BC Alexander the Great had sacked Persepolis and burnt it to the ground. Even so, what remains gives a staggering feeling of what the place must have been like.

The Gate of All Nations, Persepolis

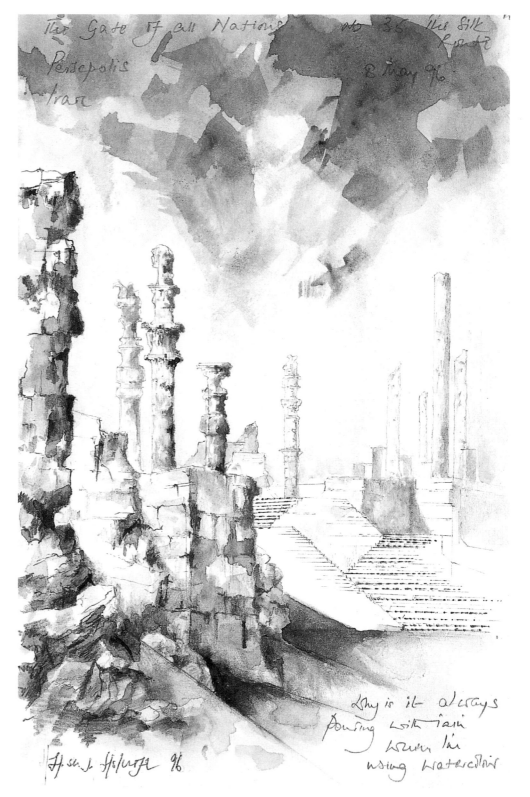

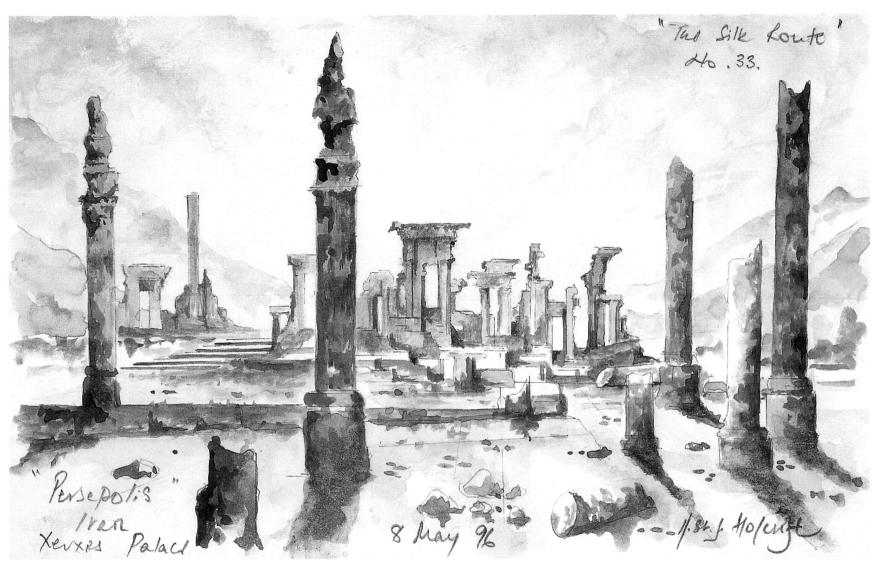

Xerxes Palace, Persepolis

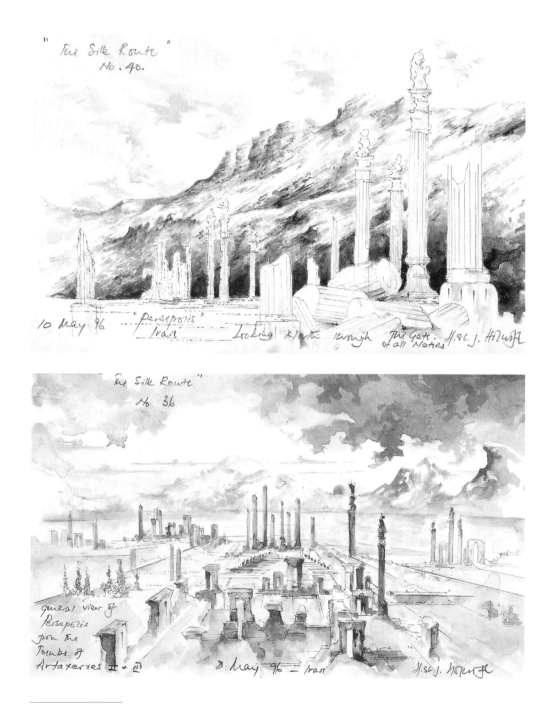

The Gate of All Nations, Persepolis

Persepolis from the Tomb of Atartaxerxes

Entrance to the Hall of 100 Columns

The Palace of Atartaxerxes

Shir Dor
aut
Tillya Kari
Madrassahs
The Registan - Samarkand.
Uzbikistan. - fingers frozen!

A.St.J. Hoberts 26 March 96

The Rejistan, Samarkand

CENTRAL ASIA

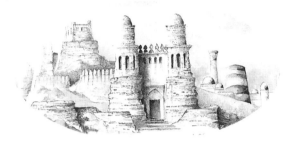

Besides the Poles, Central Asia is one of the most isolated places on the earth. A 2000-mile wide oval surrounded to the North by the swamps and forests of Siberia and bordered to the South by endless mountains. It contains no less than five deserts; the Gobi, Taklamakan, the Lop, the, Kyzyl Kum and the Kara Khum.

And yet out of this isolation has come wave upon wave of nomadic tribespeople who have laid waste to the Eurasian landmass.

In AD 200 it was the Huns.
In AD 700 it was the Seljuks.
In AD 1300 it was the Mongols, in successive waves – ending with Tamurlane establishing the biggest empire the world has ever known.

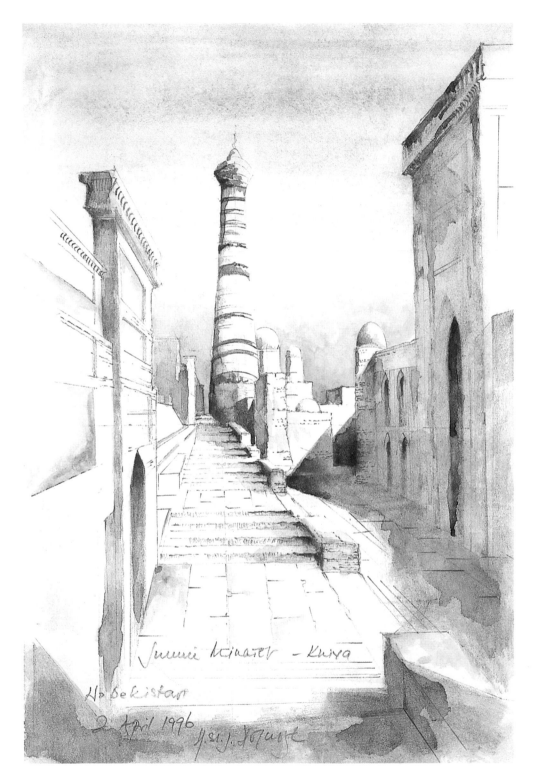

Jummi Minaret, Khiva

UZBEKISTAN

KHIVA

Khiva is exactly as it was during the height of the Silk Routes activity.

Shem, the son of Noah, is said to have founded the city in this extraordinary oasis where pomegranates grow the size of footballs.

Like Palmyra it became rich through trade; however, unlike Palmyra, it never developed itself into a power bloc. Its traders were a shifty lot who were actually thieves, brigands and pirates. The slave trade was its economic backbone. There are gruesome tales of inhumanity. Eventually Peter the Great sent an army of 4,000 men, partly to extend his influence towards India, but also to stop the Khivans taking Russians as slaves.

The army was welcomed into the city, given comfortable accommodation and methodically slaughtered to the last man that night.

So began Russia's involvement in what was to be called 'The Great Game', and Khiva became central to it.

Bukhara

Sunset, Khiva

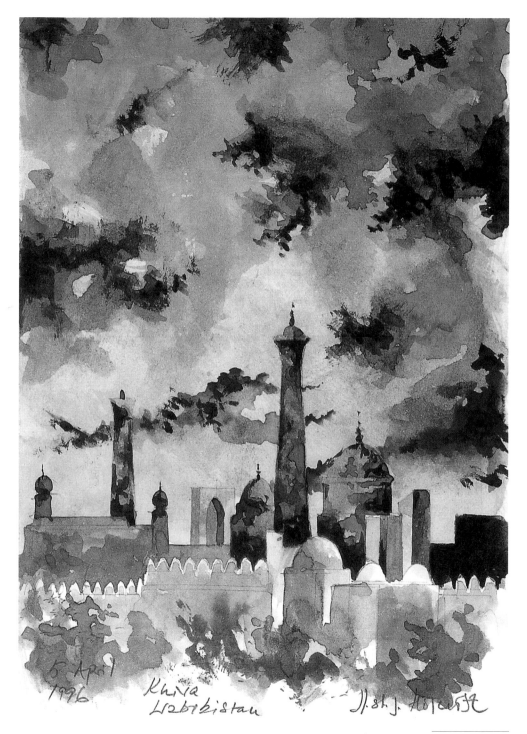

'THE GREAT GAME'

Peter The Great, as part of his modernization of Russia, had heard rumours of gold on the river Oxus and, wishing to extend his influence towards India, sent his first expedition to Khiva in 1717.

This area of Central Asia was split between warring Khanates of Khiva, Bukhara and Kokand (east of Samarkand) and therefore vulnerable to outside interest.

With Catherine the Great continuing the work of Peter, The British Empire saw Russia's southward expansion aimed straight at India – the jewel in the Imperial Crown. Russia at this time was spreading like a flood, 150 square kilometres a day.

Thus in this no-man's-land of political mystery, a game of cat and mouse began between the two empires. Spies sent on 'hunting trips' or 'scientific surveys' tried to gain influence and map the territories for their respective empires.

So began what came to be called 'The Great Game'. It threw up remarkable characters on both sides, such as Colonel Frederick Burnaby, involving amazing hardship, imagination and bravery and wonderful romance epitomized in Kipling's classic book *Kim*.

It resulted in the Crimean War, where Russia's designs on Turkey were stopped. However, although India remained British the whole of Central Asia fell under Russia's control.

The East Gate, Khiva

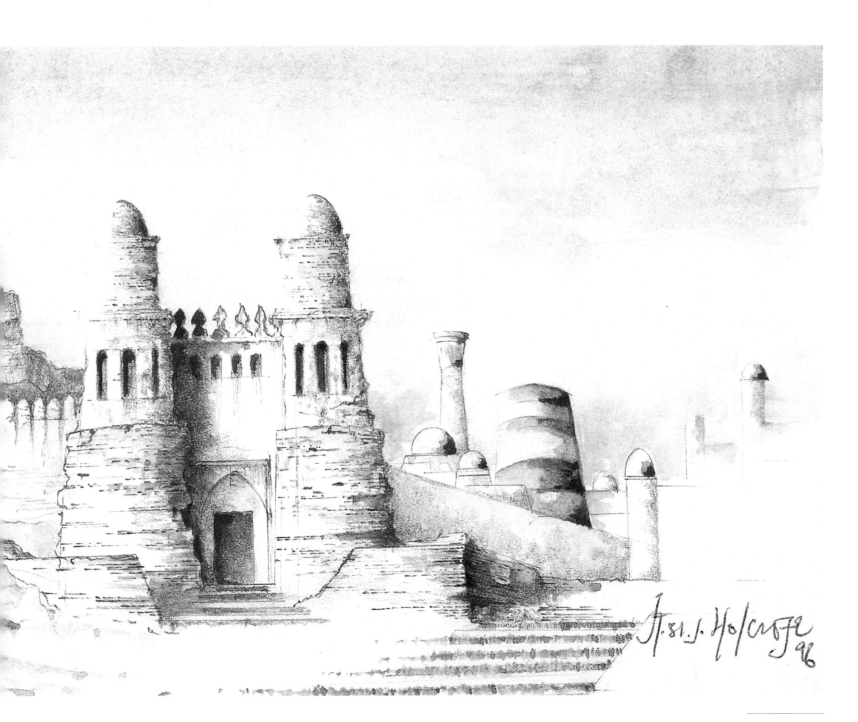

Khiva to Bukhara
ACROSS THE KARA KUM DESERT
Thursday, 4 April 1996

The road is a thin line of dead-straight tarmac which continues for eight hours, even when travelling at 60 mph.

Never have I been through such remoteness. Not in Saudi Arabia, not in the Taklamakan Desert, nor in the Sinai or the Thar Desert in India.

Not one other vehicle do we encounter. How did the likes of Burnaby and others manage it? The mind boggles at the resilience of our Victorian forefathers.

What if we break down?

No matter … I have a bottle of 'Famous Grouse'!

Chor Minor, Bukhara

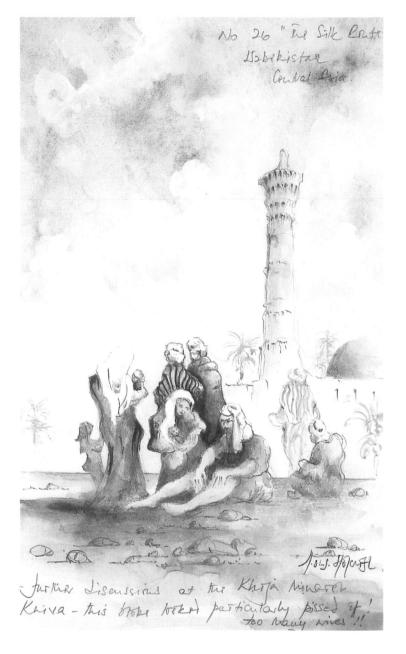

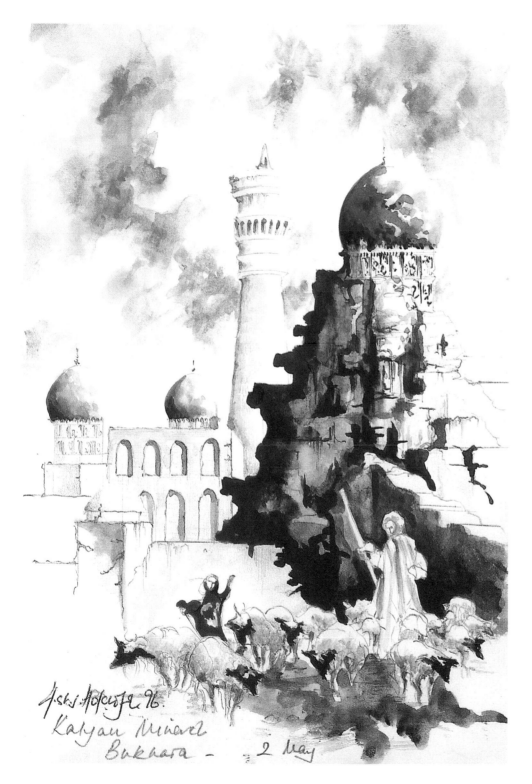

Bukhara, Uzbekistan
LANGUAGES
Tuesday, 16 April 1996

*O̲ne legacy that the Silk Route has
left is that the populations who live
along its lengths have incredible
linguistic ability. The Uzbeks all speak
both Uzbek and Russian. The majority
speak Uzbek, Tajic and Russian.
The gatekeeper of the madrassa I am
staying in speaks Uzbek, Tajic,
Turkeman, Russian, English, German
and French. Six languages … and he's
only the doorman! I feel pathetic. Here
I am, a supposedly educated Westerner,
and I barely speak two languages.*

Kalyan Minaret, Bukhara

BUKHARA

Bukhara: The Holy, The Noble, The Dome of Islam, The Pillar of Heaven.

Religion is a big thing.

Originally the religion here was fire worship, perhaps a legacy of Zarathustrianism. In AD 709 the great surge of Islam conquered it. Unlike any other part of the world that has succumbed to Islam, Bukhara refused at the beginning with immense ferocity and hardship.

This struggle was the result of another remarkable lady called Queen Quataiba. She caused no less than three rebellions. Eventually the city took on the mantle of Islam, but absorbed it into its own beliefs.

Then began a period of extraordinary enlightenment — a golden age of commercial activity due to the Silk Route and consequently a time of cultural excellence and trade. In a manner that paralleled Florence, there was a renaissance artistically fired by religion.

Unfortunately Genghis Khan arrived at the gates of the city on a Friday in March 1220. The Wind of God's Omnipotence proclaimed himself 'the scourge of God'. Not only was its entire population massacred but the city was literally levelled to the ground, and disappeared completely for 200 years.

But by the time of the Great Game it had once again become the centre of attraction.

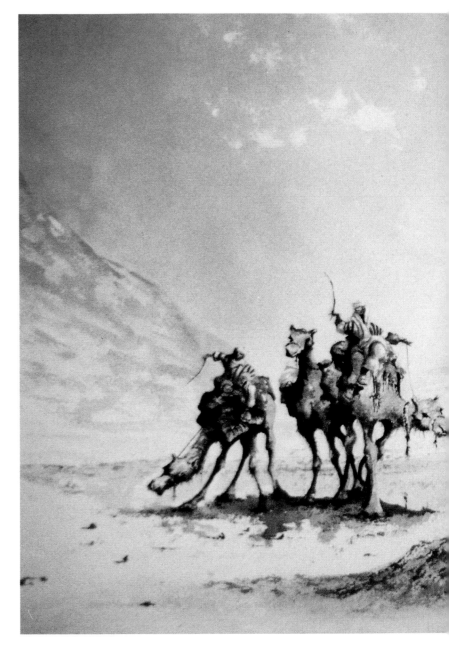

The Kara Kum Desert

THE FUTURE OF BUKHARA
Friday, 3 May 1996

This place is sadly like Moscow. The dead hand of socialism has taken its spirit. The people are intrinsically charming but have become cold because of the dreadful impersonality of the Soviet system. I suspect they will regain it: there is still a twinkle in the eye.

Any question asked involves a large group discussion. No answer is forthcoming but a chance encounter with a stranger is of absorbing interest to anyone passing by and will involve twenty minutes (and twenty people) just to ask the way.

Everything is laboured. The only hotel is an ex-Soviet Intourist one. It takes one hour to check in. The person behind the counter is only firing on one cylinder. He cannot cope with the fact that I am alone. His only experience is of 'groups' herded through the Soviet Republics by Intourist, which was the organization that controlled visitors to the former Soviet Union.

The Soviet sanitization has gone deep. Seventy years is three generations. The effect here seems far stronger, for example, than Poland. Catholicism there is still rampant; here the old mullahs are literally beggars and the madrassas have become doss houses or hostels — yet fundamentalism is just over the Oxus river, i.e. next door. Could the Bukharans go the same way?

No, their main desire is trade. Their history is of too many religions — from fire worship to Islam to even Buddhism. There is now, I believe, a very large power bloc developing in the 'ans' (Iran — Uzbekistan — Kirkistan — Turkmenistan — Pakistan etc.).

They have immense natural resources. The future I think looks very rosy for them.

Bukhara
LUNCH WITH THE FUZZ
Saturday, 4th May 1996

Bukhara is somewhat devoid of places to eat. However, outside the Main Gate is a spot where anyone who has a uniform seems to go.

By eleven o'clock it is really quite colourful. Uniforms range from yellow to green to blue, with one or two bright red. They all have wonderful hats … which would put the Household Cavalry to shame. With my trusted Guards blazer which, despite travelling rough, always comes with me, I attempt to join the splendid dignitaries.

Being a little nervous, I surreptitiously place myself at a bench with the least colourful uniforms — good old khaki — which I hope will seem unobtrusive. They don't object and, with my big shiny brass buttons, I am accepted. Conversation is obviously a little difficult, but with large pots of chi (tea) we begin to get going. There are lots of smiles, mutual bowing and, with each smile, a splendid array of gold teeth that complements the uniform.

I later discover that I am having light luncheon with the 'top fuzz'!

Food is either plov *or* sashlik. Plov *is a type of risotto with very strange bits of meat/fat in it. The* sashliks *are rather good, as long as they are eaten straight from the fire.*

This is because they are mostly fat. After two minutes they turn into wobbly white lumps, like the top of a toothpaste tube. There is also soup, which has other indeterminate things floating in it. Anyway, the four gold-jawed policemen commence lunch. With nods of encouragement I follow suit, ensuring that I am being as polite as possible, adjusting my brass buttons to look important. Politeness really means making as much noise as possible. Large lumps of lamb are dumped from the sashlik *into the soup — or the tea, it doesn't matter — and then flicked rather deftly with a wooden spike from bowl to mouth with a noise like a sluice gate opening.*

Either the tea or soup is then slurped into the mouth, followed immediately by a handful of plov *— with some more liquid from soup or tea bowl. I had just begun to get the hang of this when a new round of activity started — spitting out what just went in!*

We are basically back to the bathroom. Having eaten lumps of toothpaste and swilled them around their mouths they then spit them out — in no particular direction.

They manage to miss me, and their fellow policemen, but not the table, their own boots or neighbours. The point seems to be to make as much noise as possible. Conversation is non-existent but smiles and gesticulations abound!

Very similar to any one of my children's birthday parties.

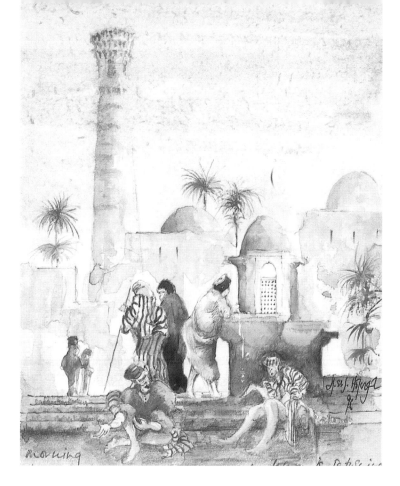

Bukhara
BAKTI AND ABDUL
Tuesday, 2 April 1995

*F*or the journey from Bukhara to Samarkand Intourist charge $200. So I decide to find a lift. In the hotel (if that's what you call it), Bakti is the waiter and Abdul the dishwasher.

Or rather, Abdul is supposed to be the dishwasher. To be precise he merely dips dirty plates into a dirty tank and takes them out again dirtier than before.

Bakti is a Tajie. He has jet-black hair, which is all spiky. They agree to take me in their car.

It was a car. It now resembles something my youngest son makes with his Meccano set. If there is an after-life they are doing their damnedest to get there as quickly as possible. There is a positive self-destruct syndrome. They neither look where they are going — or seem to care. Bakti's foot is merely slammed down on accelerator or brake at periodic intervals, whilst Abdul does the steering. Two large speakers dangle from the roof of the car ominously close to my ears.

'You like music?' I smile. Very silly of me.

What comes next is a chorus of mullahs calling everyone to prayer with high-pitched voices to rival Maria Callas's.

After four hours of sheer terror and bursting eardrums we arrive in Samarkand. Despite the terror, and because of their infectious charm, with relief I give them $50, which for them is a fortune — over a month's wages.

With massive grins they drive away like naughty little schoolboys — delightful.

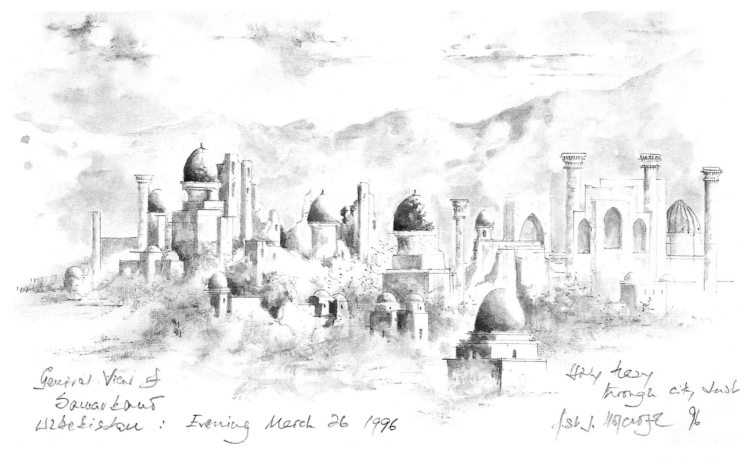

General View of
Samarkand
Uzbekistan : Evening March 26 1996

Holy hazy
through city, dust
[illegible] 96

Samarkand, Uzbekistan

SAMARKAND

The name conjures up all sorts of romantic ideas. In history it has been described as Jewel of Islam, Pearl of the East, Centre of the Universe, Garden of the Soul, Mirror of the World.

The evidence for all this is actually still there, and so is the romance. But the ravages of time, and the most hideous Soviet sixties buildings that surround, penetrate and envelop it, have destroyed it.

A thriving city in the time of Babylon and Rome, it was conquered by Alexander the Great, Genghis Khan and then Tamurlane. He made it the capital of his empire and constructed a series of vast buildings which were to reflect his own power and might. Despite decay they still inspire awe.

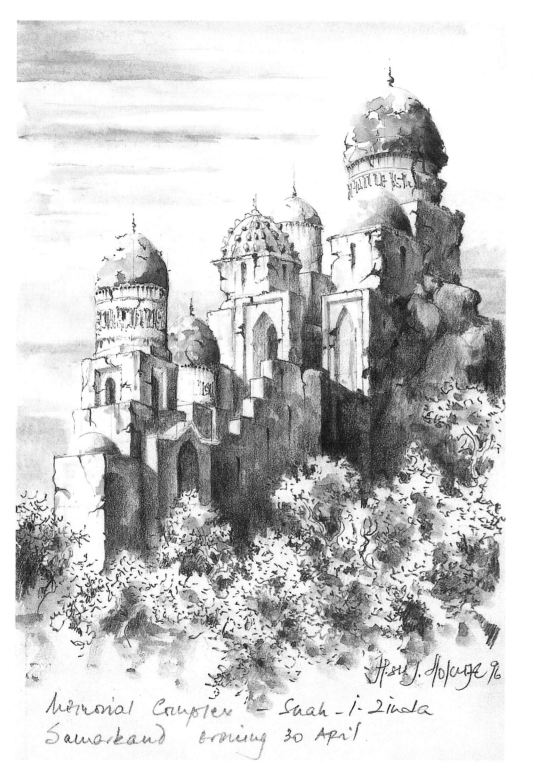

Memorial Complex — Shah-i-Zinda
Samarkand evening 30 April.

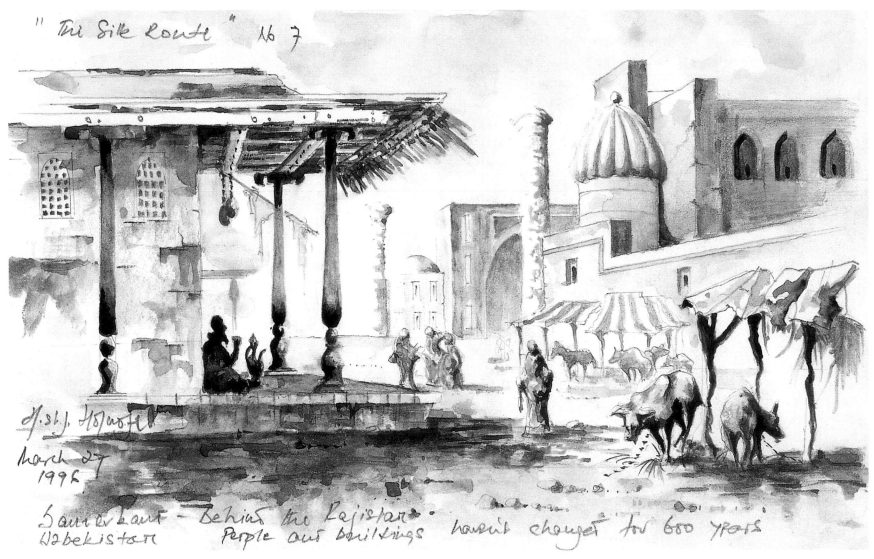

"The Silk Route" No 7

Samarkant – Behind the Rejistan. People and buildings haven't changed for 600 years

Uzbekistan

March 27 1996

Behind the Rejistan, Samarkand

TAMURLANE

The last of the Mongol nomads to shock the world. Yet even his great great grandson Babur was to form the Great Mogul Empire of India.

Timur was born in 1336. When young he was wounded in the leg and became known through bastardized English as 'Timur the Lame' or eventually as Tamburlane or Tamurlane.

For thirty years he swarmed over the lands of Genghis Khan, his ancestor, from Moscow to Delhi to China. Eighteen million died in an apocalypse of blood and suffering, marked by pyramids of skulls, that surpassed the destruction created by his ancestors … Heads that were not left in the pyramids were used as cannonballs or else captives were piled alive on top of one another and cemented into clay towers, 2,000 at a time.

The effect is still very relevant to Russian history today. Russia never recovered from the shock.

Yet he did produce some lovely buildings.

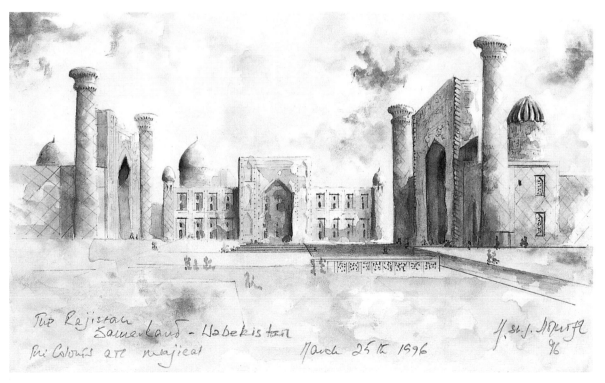

Tilya Kari Maddrassa,
Samarkand

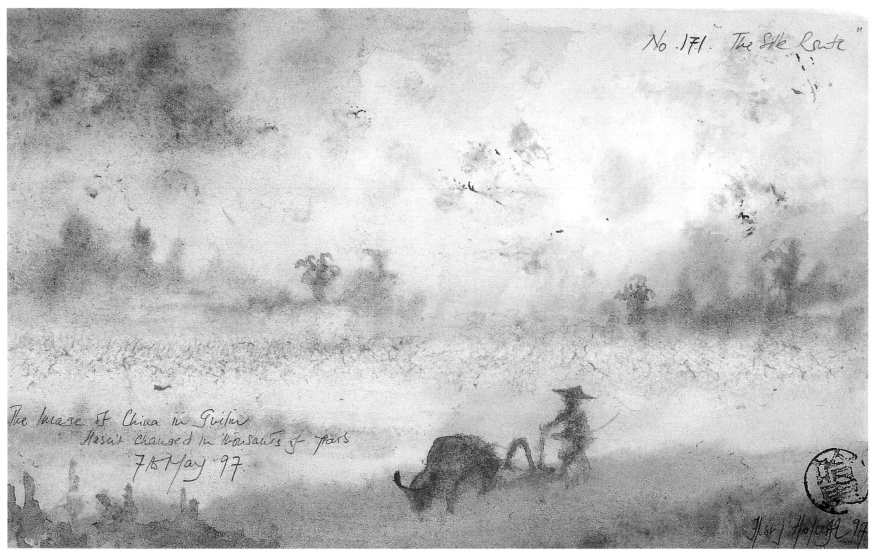

The Image of China, Guilin

CHINA

THE MIDDLE KINGDOM

China is The Middle Kingdom. For the Chinese this means they are halfway between Heaven and Earth. The Emperors had the 'Mandate of Heaven' and were called 'The Sons of Heaven'. So intrinsically do the Chinese feel this superiority, that there was no chance that Christianity, with its claim that there was another Son of God, could ever take hold. Buddhism, on the other hand, did.

The rest of the world is *guaolo* – 'foreign devil', and to the Chinese we have never held any interest. Except for one thing. Money.

Just as the Silk Route provided China with her wealth, so today she is opening up to trade and has the potential to be the power bloc of the twenty-first century. The Chinese have one major drawback … they only speak Chinese. In an age driven by information technology in English, India may possibly have the edge. Nonetheless 1.2 billion people are something to be reckoned with.

THE CHINESE –
TRYING TO UNDERSTAND THEM

Something to do with the numbers. Every fourth person on the planet is Chinese. They have a hive instinct.

Historically this may come from the severity of the Yangtze and Yellow rivers in times of flood.

To avoid the appalling natural disasters, where millions could drown each year, incredible co-operation was needed in the immense embankments that had to be built.

Three examples of this extraordinary mass co-operation spring to mind.

1. In 1973 I was in Quandong (then Canton). The Pearl river was being dredged. 300,000 men and women, moving like worker ants, were scratching a whole port out of the earth with bare hands. Not one machine was in evidence. Gargantuan columns of people, with two panniers swinging from poles across their shoulders, painstakingly moved down one side of the gorge, filled their pannier with earth, moved up the other side, deposited the earth and returned, in an enormous circle the size of Heathrow Airport. Frightening.

2. The ability for mass co-operation is reflected in Chinese characters. The population could act with a 'hive-like' instinct because the written language is in fact pictorial, i.e. illiteracy did not exist. Directives and slogans were pictures that everybody could respond to. Nothing like this could happen in the West because of our development of alphabets and the written word.

3. The inability of any Chinese to understand the concept of travelling alone. Wherever Sarah or I went we were regarded with astonishment, not because we were *guaolo* or 'foreigners', but because they could not cope with the concept of individuality; we were not part of a group.

How else can one explain the madness of the Cultural Revolution and the disaster of the Great Leap Forward?

Stalinist Russia created similar horrors. I believe that was from the autocratic inheritance of serfdom and Tsarist regimes, together with apathy.

But China is different.

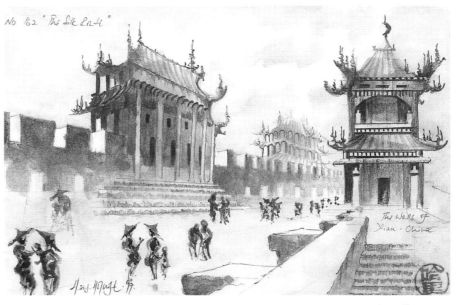

The walls of Xian

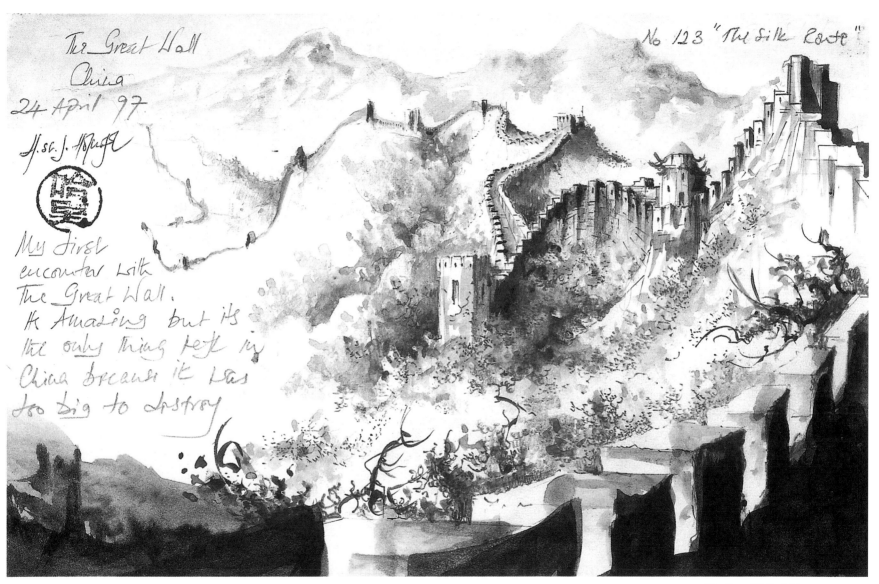

The Great Wall
China
24 April 97

No 123 "The Silk Route"

My first
encounter with
The Great Wall.
It Amazing but its
the only thing left in
China because it was
too big to destroy

The Great Wall of China

China 75

ARCHITECTURE

Architecturally China is remarkably lacking. This is because of the 'Mandate of Heaven' which gives legitimacy to every generation for the overthrow of the current power elite. It also means that everything is torn down and destroyed every twenty-five years. The present Chinese 'openness' to the world and trade is a reaction to the Cultural Revolution and the isolation of Chairman Mao in the 1970s.

The only thing left is the Great Wall, which was too big to pull down and the Terracotta Warriors, because they were underground and only discovered twenty years ago. Otherwise China is architecturally barren.

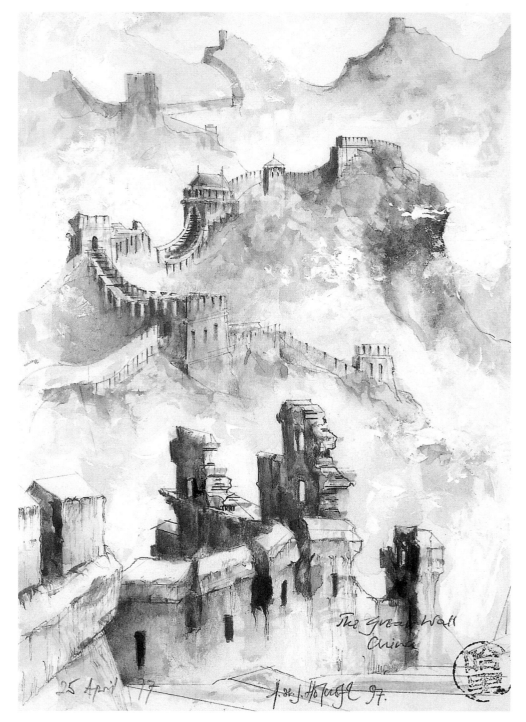

The Great Wall of China

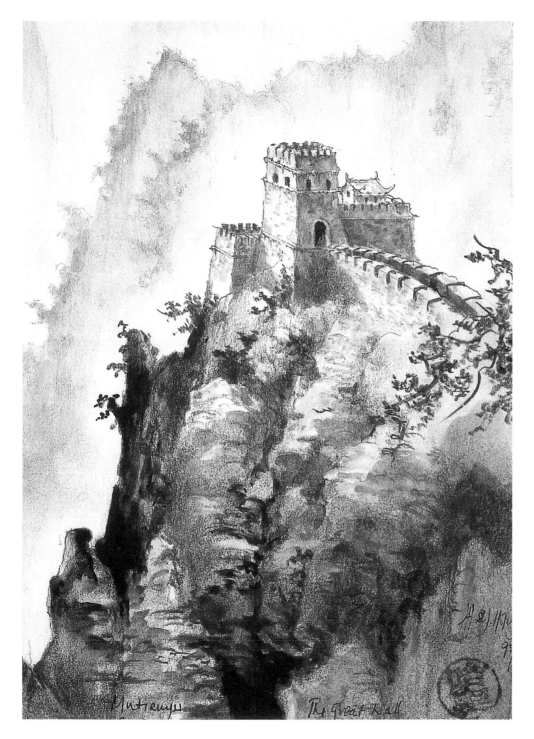

Mutianyu The Great Wall

The Great Wall of China

XIAN

Xian ranked with Rome and Constantinople as the greatest city in the world. It was founded by the Xia dynasty some 3,000 years BC. This is legendary as no documentation exists. Known history begins with the Emperor Quin around 300 BC.

In 1974 a peasant digging a well stumbled on the major archaeological discovery of this century. The Emperor Quin had gone to his grave protected by an army of 8,000 of his soldiers, with their weapons still sharp after 2,000 years, lined up ready for battle – the Terracotta Warriors. Further vaults are still being discovered, producing command posts, cavalry squadrons and chariots and yet this may only be the beginning.

All that has been discovered so far is part of his army. His tomb, currently still underground and marked only by a massive hill, is the largest mausoleum on earth. Accounts state that the outer walls are six kilometres in circumference, with the vault being two kilometres wide and containing 'Rivers of Mercury', 'Ceilings of Pearl' and 'Statues of Gold'. The artisans who built it were buried alive within it to keep its secret. It is there today but no one can work out how best to get into it.

What an Aladdin's cave when they do!

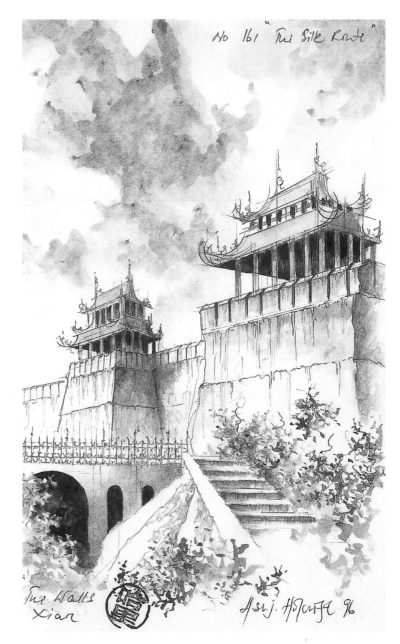

The Walls of Xian

Authority in China
TURPAN
Thursday, 8 May 1997

We stop next to the town courthouse. Outside, a 'sentencing' is in progress. Chinese law seems based on the concept of 'sacrifice the chicken to check the monkey'.

Fifteen desolate souls, their trials and convictions concluded, are to be given sentence. The whole town is here. They are all dressed up, children included, for the day out. I am witnessing the equivalent of a public execution at Tyburn in the sixteenth century.

The Party Officials sit on a raised dais, while the criminals are paraded manacled. They are then all lined up and each one ordered to step forward individually. Sentence is given while the public gawp. Seven years for a rapist, five years for a thief, and execution for a drug dealer and arms dealer. Sarah and I watch horrified at this macabre spectacle, but the Chinese giggle like children at a circus while the unfortunates are hauled off for incarceration or death. Another instance of my inability to understand them.

1000 Buddha caves, Turpan

The Yangtze
DOWN THE YANGTZE RIVER
Wednesday, 16 May 1997

*E*veryone knew that the biggest engineering project in the history of mankind — other than the Great Wall — was about to be finished. Everyone except the British.

The Chinese decided to dam the Yangtze river in the days of Mao. They have now nearly finished.

The project will:
1. Submerge the Three Gorges (together with the Grand Canyon, one of the most spectacular sights on Earth).
2. Dispossess four million people — a city of one million will be totally submerged.
3. Cause all sorts of unpleasant things to happen to unsuspecting hedgehogs and billions of related fauna.
4. Alter the climate.

But it will also:
1. Look good
2. Stop a lot of people drowning every year.
3. Provide electricity for lots of fridges, etc.
4. Make a wonderful military target.

This is not the perfect synopsis of the pros and cons, but it's not far off.

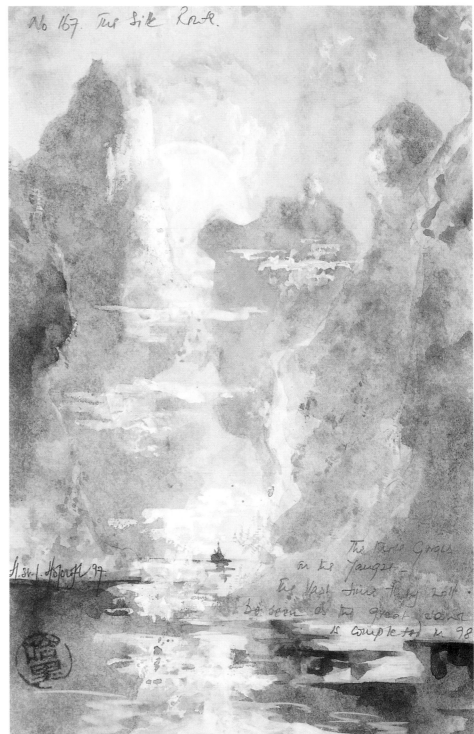

The Yangtze
ENTERTAINMENT ON BOARD
Friday, 18 May 1997

Entertainment on board takes on an extraordinary diversity. We have four days/nights on board a boat going down the Yangtze river.

It includes:
1. Watching the scenery. The Three Gorges are simply spectacular.
2. Watching the Spanish. Dressed like gorgeous flamenco dancers they fill the boat with the most wonderful sophistication and take over the salon and bar. The atmosphere is similar to the 1920s and '30s.
3. Watching the dead. They float by. The Yangtze swallows and drowns people every day. Huge bloated carcasses just pass by and you look — who was he/she, where is the family? Have they also perished? Are they still waiting for their loved ones to return?
4. Watching the boats crash. The Gorges are horribly turbulent. Boats try to negotiate rocks but then bump into them. They then sink.
5. Watching the barman. With particularly cosmopolitan passengers the demand for alcohol is impressive. The Spanish again, but the Italians are right behind. He runs about like a demented bluebottle.

Anyway, this is the last year that anybody on the face of the earth can see the Three Gorges. As the whole world knows — except the English — the whole world seems to be here. It feels like every boat in China is on the river. These are big boats. The Yangtze is a very big river. They are like cross-channel ferries.

We board The Princess Jeanine. *A very smart German boat built in 1994. Luxury. Together with: Japanese, Americans, Germans, French, Spanish, Italians, Dutch and even Puerto Ricans. Is there one other British person? No — just us. The whole world is talking excitedly of the last opportunity to see the Three Gorges. Not one British travel agent, to my knowledge, was aware of this, and consequently, not one other English person is on board. Why are we becoming so insular?*

LEFT: *The Three Gorges, The Yangtze*

BEIJING

Beijing is the very centre of China just as Paris is the centre of France. It became prominent 4,000 years after Xian when in 1200 Genghis Khan obliterated it and his grandson Kublai Khan decided to live there.

The Ming dynasty in 1300 built the Forbidden City, which is about the only architectural legacy the Chinese have managed to leave.

The Gate of Supreme Harmony, Beijing

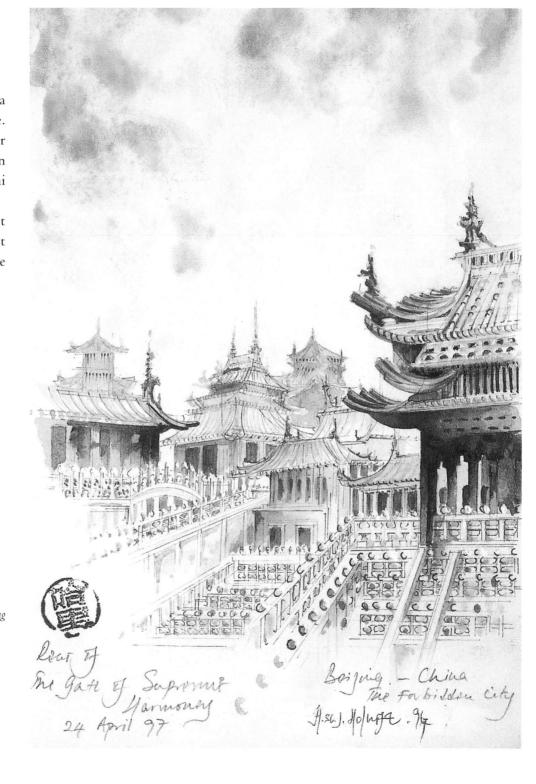

Rear of
The Gate of Supreme
Harmony
24 April 97

Beijing — China
The Forbidden City
A.S.J. Holway. 97

No 122 "The Silk Route"

J.St.J. Holcroft 96

The Summer Palace : Beijing China
built by Xisci — A victorian Monstrosity
Looks like Hyde Park on a bank Holyday
The Chinese have living exactly the
Same as The Victorians.

The Summer Palace, Beijing

No 116 "The Silk Route"

The Temple
of Heaven
Where the Emperor
made the ultimate sacrifice for
the benefit of the people
Beijing — China *J.St.J. Holcroft 97*

The Temple of Heaven, Beijing

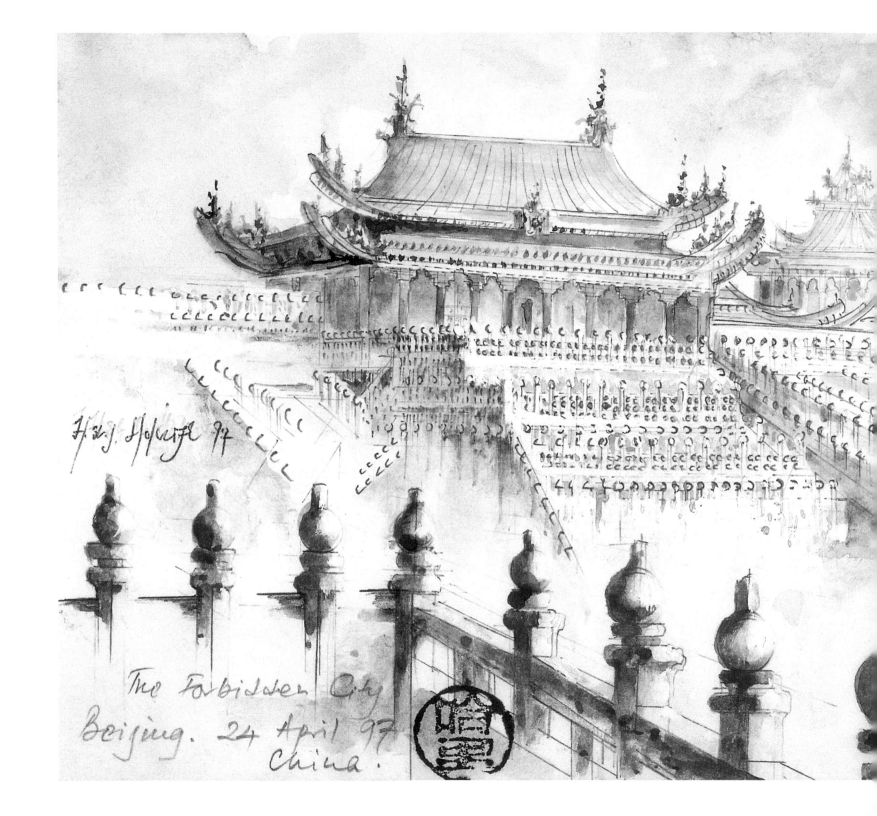

The Forbidden City
Beijing. 24 April 97
China.

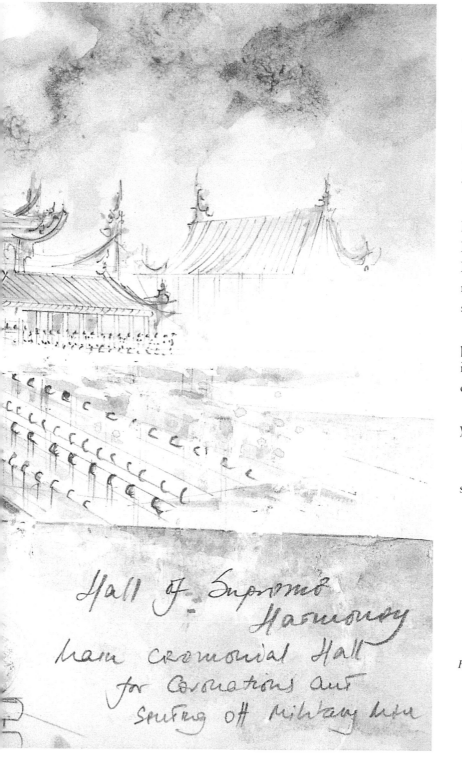

Hall of Supreme Harmony, Beijing

THE FORBIDDEN CITY

Forbidden, because for over 500 years it sat in total isolation. Instant death if you dared enter. The Ming dynasty and the Quing (Manchu) sat here from 1368 to 1911, never leaving it except once a year to go to the Temple of Heaven.

The original city was built by a million people. From here the Emperors – 'The Sons of Heaven' – ruled The Middle Kingdom. Somewhat erratically. Eunuchs were the Mandarins who wielded the power. The Emperors became more and more lost in their own secluded worlds. One spent his whole life doing carpentry.

What now exists is mostly eighteenth-century. The place was constantly going up in flames as a result of the internal intrigue of the eunuchs and the female concubines of the Emperors.

As you wander through the back alleys of the city today, you can still palpably feel 500 years of intrigue.

Imagine 2000 eunuchs versus 2000 concubines in a struggle for power!

GUILIN

If China is architecturally barren, then Guilin makes up for it. The limestone mountains provided the inspiration for Chinese paintings which eventually found its way to Europe in the form of the blue and white 'Willow Pattern' china.

Views of Guilin

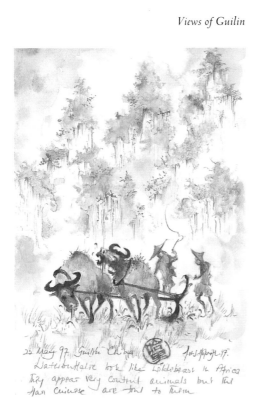

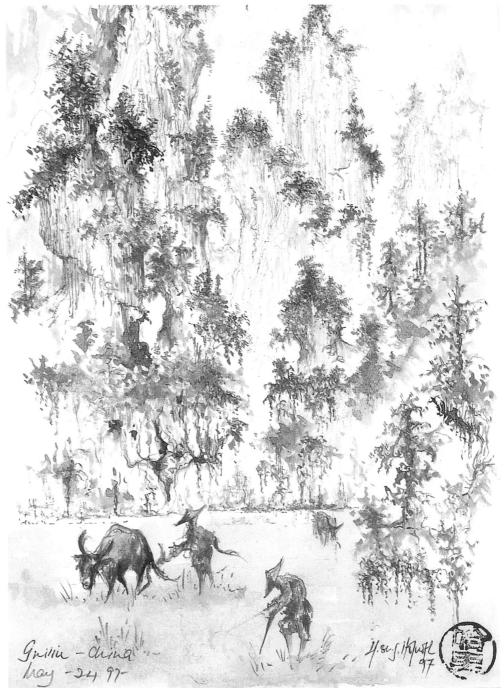

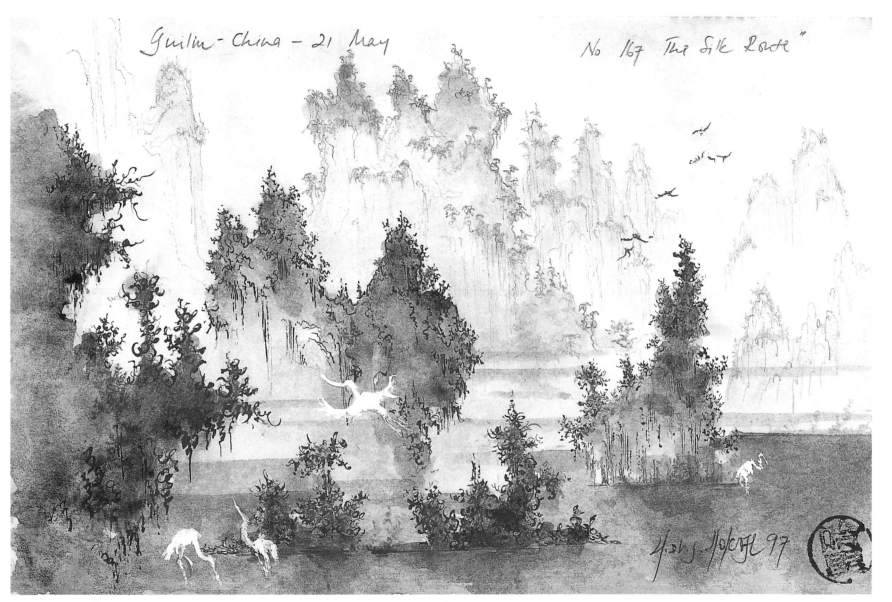

Guilin — China — 21 May

No 167 "The Silk Route"

Guilin

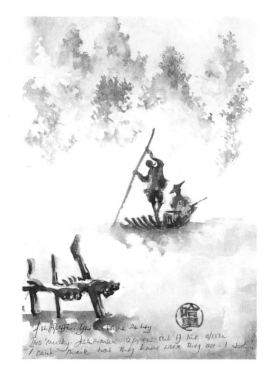

By the 1500s the Silk Route had declined and was finished.
In its place arose the Sea and Spice Routes, which were to prove as important in the
history of Eurasia and Europe as the Silk Route. But that is another story ...

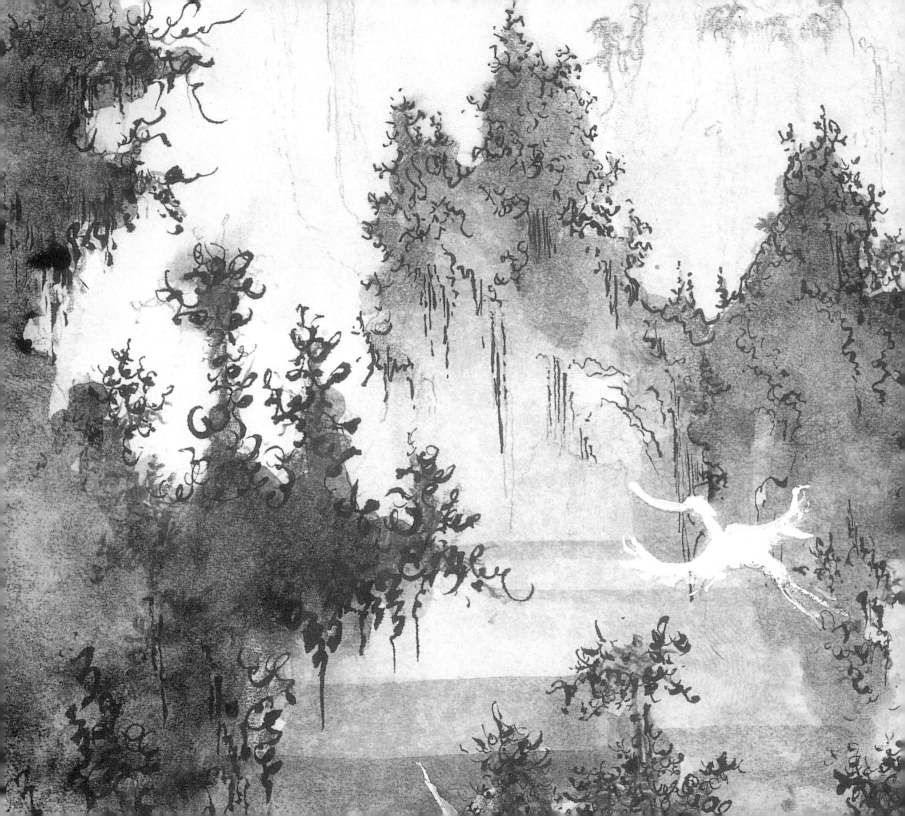